IMAGES
of America

ALFRED AND ALFRED STATION

Alfred + area
where Peter & I
have lived for
56 years.
Thank you for all your
kindness
Terry

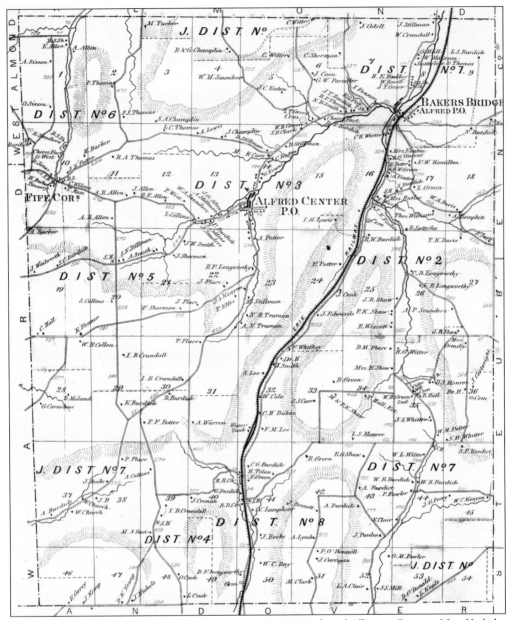

The town of Alfred was depicted by this map in the 1869 *Atlas of Allegany County, New York*, by D. G. Beers and Company. (Courtesy of Alfred University Archives.)

On the cover: The Celadon Terra Cotta Company's office building was used not only to conduct business but also as a showpiece for its products. It was such a unique structure that a replica was exhibited at the 1892 world's fair in Chicago. A devastating fire destroyed the plant on August 26, 1909, leaving only the office building intact. (Courtesy of Jean B. Lang Western New York Historical Collection.)

IMAGES
of America

ALFRED AND ALFRED STATION

Laurie Lounsberry McFadden

ARCADIA
PUBLISHING

Published by Arcadia Publishing
Charleston SC, Chicago IL, Portsmouth NH, San Francisco CA

Printed in the United States of America

Library of Congress Catalog Card Number: 2007924624

For all general information contact Arcadia Publishing at:
Telephone 843-853-2070
Fax 843-853-0044
E-mail sales@arcadiapublishing.com
For customer service and orders:
Toll-Free 1-888-313-2665

Visit us on the Internet at www.arcadiapublishing.com

*This book is dedicated to members of the Alfred community,
past and present, who understand the importance of preserving local
history and who have worked diligently throughout the years to ensure
that Alfred's rich heritage can be passed on to new generations.*

CONTENTS

ACKNOWLEDGMENTS

In particular, I wish to thank those who supplied images for this book and/or provided historical detail for the captions: Peggy and Dan Rase, Angela and David Rossington, David Snyder, Jean Lang, Thelma and Lyle Palmiter, Harold and Bev Snyder, the Stearns family, David Clarke, G. Douglas Clarke, Sandy McGraw, William B. Crandall, Alan Littell, Ellen Shultz, Sandy Greiff, Elaine Hardman, Laurie DeMott, Hillel at Alfred, Sherry Volk, Dick Green, Clinton Ormsby, Diana Hovorka, the Tomm family, MaryLou Cartledge, Gwen Burzycki, Pete and Kathleen McDonald, Mary Trouslot, Marc Rawady, Stacy Pierce, Judy Burdick Downey, A. E. Crandall Hook and Ladder Company, St. Jude's Chapel, Alfred United Methodist Church, Union University Church, Alfred University, Alfred State College, New York State College of Ceramics at Alfred University, Jean B. Lang Western New York Historical Collection at Hinkle Library, Alfred Historical Society, and Baker's Bridge Association.

Special thanks go to Sherry Volk for her careful reading of the draft text and for her well-constructed suggestions for improvements to it.

As this book is celebrating the bicentennial of the town of Alfred, thanks must also be given to those folks who have worked over many months planning the events to recognize this milestone: Becky and Craig Prophet, Bob and Sherry Volk, Patricia Bancroft, Joe Dosch, G. Douglas Clarke, Laurie Lounsberry McFadden, Hope Zaccagni, and Keith Gregory.

No book ever appears without a supportive editor, in this case Pam O'Neil from Arcadia Publishing, who answered all my questions and kept me within the necessary deadlines.

And finally, I want to thank my parents, Robert and Mattie Lounsberry, my husband, Mark, and son, Sawyer, for their everlasting love and support.

INTRODUCTION

To the casual visitor to Alfred, a first glance while driving through either the village of Alfred or the hamlet of Alfred Station may not provoke much thought about the rich history that lies underneath. But as one begins to see roofs covered in terra-cotta tiles, small family-owned businesses, educational edifices, beautifully styled older homes, and announcements for various community-sponsored events, it becomes apparent that beneath that initial layer, there is so much more to discover, stories waiting to be told, and history worth knowing.

The first inhabitants of Alfred were the Seneca, members of the Iroquois Confederacy who hunted and lived throughout the region. In May 1807, Clark Crandall, Nathan Green, and Edward Green, following the Native American trails, arrived on foot from eastern New York to begin a new life. The town was officially incorporated on March 11, 1808. Two distinct living centers emerged within its borders: Baker's Bridge (later named Alfred, then Alfred Station) and the village of Alfred, originally incorporated as Alfred Centre on September 1, 1887. Also of note is the area nicknamed "Tinkertown," located between the two main settlements and so called because of the many small industries (tinkers) found there in the early years.

Life was hard for the early pioneers and those who followed, as they worked to clear the land, built homes, and attempted to live on the crops and livestock they raised. Particularly difficult was the "Starving Year" of 1816, also known as "the Year Without a Summer," as snow and ice formed every month of the year. The killing frosts wiped out most of the crops, making it a time of little food and great suffering. Typical of close-knit communities, the people made it through by caring for one another and sharing their precious stocked supplies.

As people got settled and land was better cleared, they were able to focus on businesses other than farming. Commerce began to thrive as products were made for sale, both locally and regionally: for example, potash, maple sugar, cheese, and surplus crops.

As most of the early settlers were Seventh Day Baptists, they brought their ideals and common religious practices to Alfred, ideals that strongly influenced the development of the town for over 150 years. Their Saturday Sabbath keeping meant that businesses were closed on Saturdays and open on Sundays. They were fairly liberal minded. As a result, they were staunch supporters of abolition and worked to abolish slavery by vocally opposing it (a resolution was passed against it at their 1836 general conference), participating in the Underground Railroad, and volunteering to fight in the Civil War. They were also much more open in their attitude toward women's rights than most other people of their time.

The opening of the Erie Railroad in 1851 had a major effect on day-to-day life in Alfred. Agricultural goods (including dairy and cheese products) were now easily shipped to larger

markets, and travel between cities was opened up as passenger trains ran the lines. A notable section of the railroad became known as Tip Top. Located in the area once referred to as both Lanphear Valley and Railroad Valley (about four miles south of Alfred Station on State Route 21), it was so named because it is the highest point on the Erie line between New York City and Chicago. Early steam trains had to work hard to make it up the steep grade. If they failed, they had to back down and try again.

Small and large businesses flourished in the town during the 19th century, as did the educational system. The Alfred Select School opened in 1836 to provide an education beyond the local one-room schoolhouses. Open to both men and women, it soon grew to become Alfred Academy in 1843 and was incorporated as Alfred University in 1857. Due to the liberal nature of the townspeople and to strong leaders like William C. Kenyon, Jonathan Allen, and his wife, Abigail, the students were exposed to unusually early support for women's rights and equality for all people. Famous speakers often came to town: Frederick Douglass, Julia Ward Howe, Sojourner Truth, Susan B. Anthony, and Elizabeth Cady Stanton, to name a few.

The Celadon Terra Cotta Company, cofounded by John Jake Merrill, opened in 1888 and was soon producing decorative roof tiles made from the local shale, which, when fired in a kiln, turned a distinctive reddish color. Many structures in Alfred still have roofs constructed with these tiles. As a New York State tax commissioner, Merrill was also instrumental in obtaining the passage of the bill establishing the New York State School of Clayworking and Ceramics (currently the New York State College of Ceramics) at Alfred University in 1900. A second factory, operated by the Rock Cut Clay Company, opened in Alfred Station and produced bricks and roofing tiles.

Continuing the expansion of educational offerings, the School of Agriculture opened with more state funding in 1908 as New York State looked for ways to provide rural youths with instruction in agriculture and domestic science. This school was eventually incorporated into the State University of New York when that formed in 1948 and is today known as Alfred State College.

While the institutions of higher education play a central role in Alfred's daily activities, it is important also to remember that no town is complete or flourishing without volunteer organizations that work toward noble and good causes, or the businesses that provide essential goods and services. Alfred's history is full of such organizations and businesses, some of which have operated for decades while others lasted only a short time.

Many wonder how Alfred got its name, but no one can give a definitive answer. The best guess, based on local legend, is that the landscape reminded the early settlers of the English countryside and they named it after Alfred the Great. Another theory is that since the Seventh Day Baptists valued education so highly, they named it after him as he is also known as the "Education King."

Whatever the truth, the community of Alfred prides itself not only on its role in education (preschool through doctoral programs) but also on its long-standing and rich heritage. This book is certainly not comprehensive, and many people, events, businesses, and organizations are not included, not because they were not worthy but because of limited space. Hopefully the following images are a good enough representation of the beloved history within the town and village of Alfred that readers will be inspired to seek out and learn more.

One

BUSINESS AND AGRICULTURE

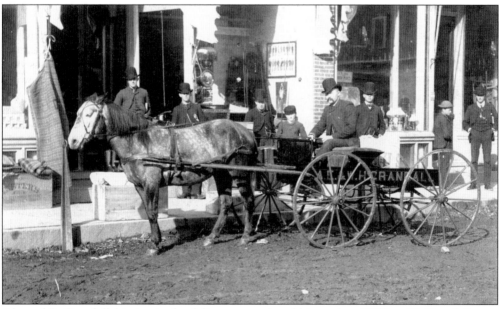

Almond E. Crandall (sitting in the delivery wagon) and his nephew William H. Crandall were prominent citizens in Alfred during the late 19th century. Together they owned a general mercantile store and an insurance company. Additionally, Almond was a driving force behind the local fire company, which bears his name; William was involved with the University Bank and the Alfred Mutual Loan Association and was a trustee and treasurer for Alfred University. (Courtesy of Jean B. Lang Western New York Historical Collection.)

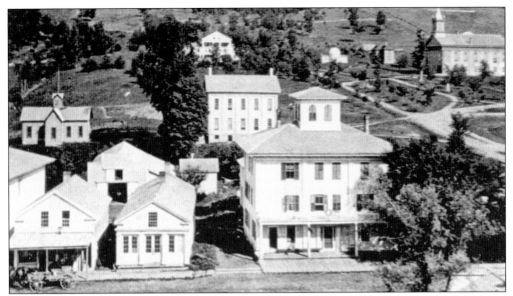

The Burdick Hotel, once a prominent feature on the east side of the village's Main Street, was located where Carnegie Hall stands today. The small building in the upper left of this mid-1880s photograph was the early gymnasium at Alfred University. Directly behind the hotel is Burdick Hall, and above that is the White House (used as the university president's residence). The original observatory and Alumni Hall can be seen in the upper right. (Courtesy of Alfred University Archives.)

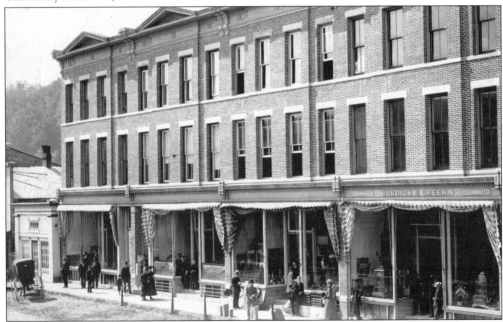

The road is now paved, the hitching posts are now parking meters, and the buggies have been replaced by cars, but this 1870s village building still actively supports area businesses, even if the typical shopper no longer wears a top hat and suit. The small white building on the left was moved in 1912 and eventually became what is known today as the Box of Books Library. (Courtesy of Alfred University Archives.)

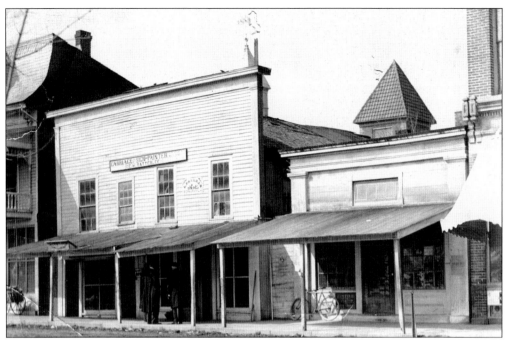

The village's Main Street, around 1912, has always been home to small family-owned businesses. The small building on the right still exists as a section of the Box of Books Library. The two towers in the background belong to Village Hall (left), then known as Firemen's Hall, and the Seventh Day Baptist Parish House. (Courtesy of Jean B. Lang Western New York Historical Collection.)

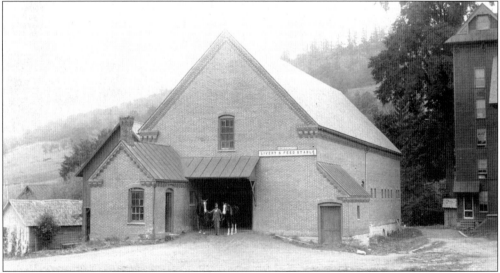

Livery and feed stables were an essential part of everyday life before automobiles. University students and local community members would have used this facility run by Hoard and Clarke at the dawn of the 20th century. It also hosted the university's blacksmithing classes. Located behind the east side of Main Street, the stable was situated next to Burdick Hall, a onetime boardinghouse for men attending Alfred University. (Courtesy of Jean B. Lang Western New York Historical Collection.)

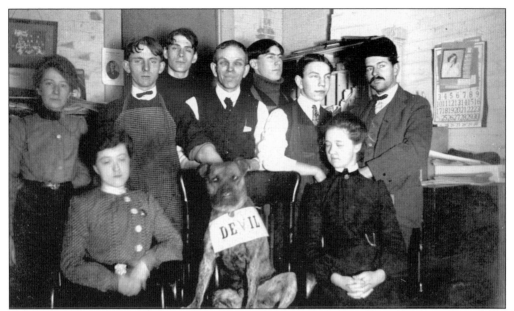

The *Alfred Sun* newspaper's first issue appeared on December 6, 1883. In 1885, Frank Crumb, center, took over the newspaper and continued as its editor until 1951, when he sold it to Eugene VanHorn. Frank's son, Ralph Crumb, is standing to his left. The newspaper ceased publication in June 1970 but was resurrected by Gary Horowitz in June 1973. David Snyder became editor in June 1976, purchased the newspaper in 1979, and continues to publish it today. (Courtesy of Jean B. Lang Western New York Historical Collection.)

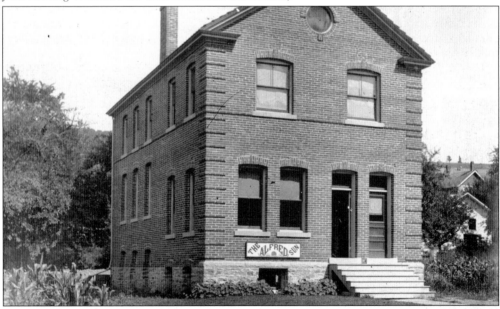

Sun Publishing Company began in 1883 and continues to operate out of this 1895 building at 11 South Main Street. In addition to publishing the *Alfred Sun* newspaper through 1970, the company's commercial printing presses have churned out innumerable pamphlets, catalogs, handbills, reports, books, and so on for the community and local businesses. (Courtesy of Jean B. Lang Western New York Historical Collection.)

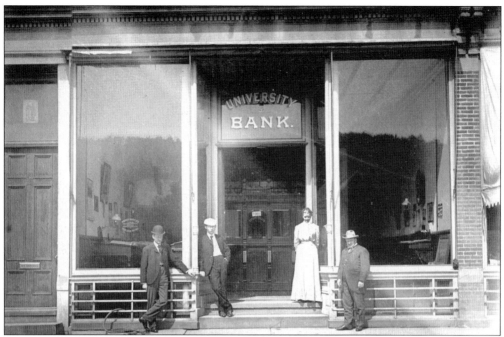

Established in 1882, the University Bank operated at 17 Main Street until 1951, when it consolidated with the Citizens National Bank and Trust Company of Wellsville. It was closed on Saturdays and open on Sundays until 1953, as was typical of businesses in Alfred that served the Seventh Day Baptist community. The bank moved from this location on Main Street to a separate building constructed in 1964 (today's Community Bank). Above, from left to right are E. E. Hamilton, E. A. Gamble, Jennie Sherman Pinchin, and bank president William H. Crandall. (Above, courtesy of G. Douglas Clarke; below, courtesy of Jean B. Lang Western New York Historical Collection.)

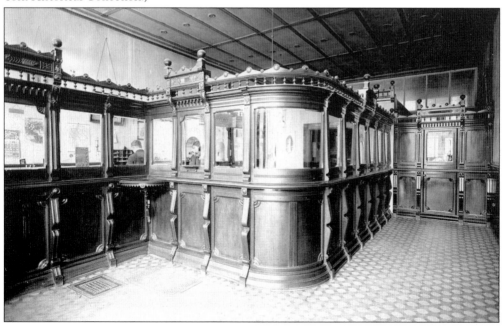

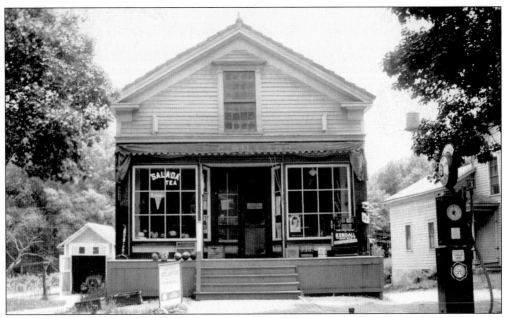

Clyde and Etta Willard ran a general mercantile in Alfred Station, from around 1926 to 1944. One can see that automobiles have taken hold by noting the car in the garage, the advertisements for Atlantic Gas and Kendall Oil, and the gas pump in the foreground. Today this building is home to the Canacadea Country Store. (Courtesy of Baker's Bridge Association.)

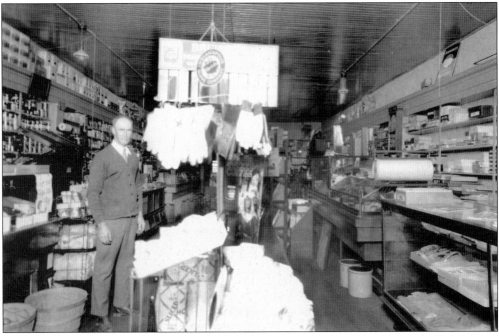

Clyde Willard shows off the many items for sale in his store in Alfred Station. (Courtesy of Baker's Bridge Association.)

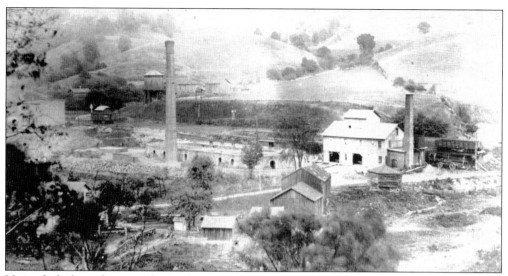

Using shale from the area, the Rock Cut Clay Company, or the Alfred Clay Company as it was commonly called, formed in Alfred Station in 1892. In operation until about 1911, it produced bricks and roof tiles. (Courtesy of Baker's Bridge Association.)

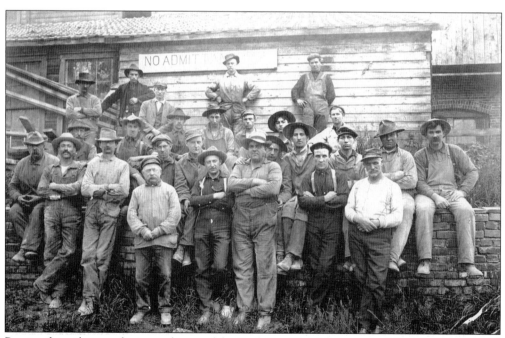

Pausing from their work are employees of the Rock Cut Clay Company in Alfred Station, around the dawn of the 20th century. (Courtesy of Baker's Bridge Association.)

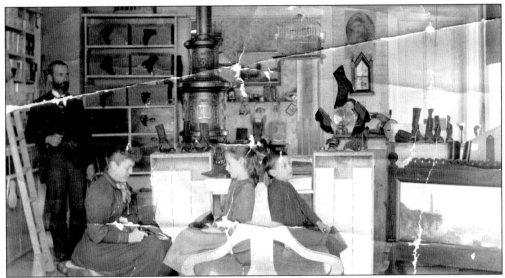

Walter Wilbur and his wife ran a shoe store at 44 North Main Street during the mid- to late 1800s. (Courtesy of Jean B. Lang Western New York Historical Collection.)

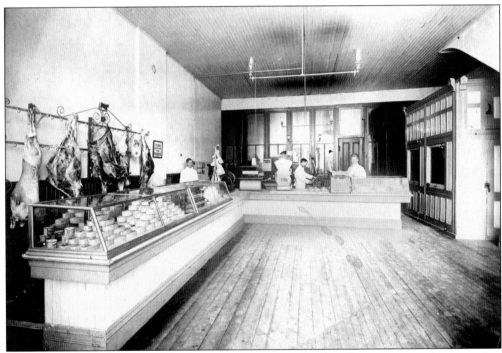

From left to right, Ralph, Ernest, and John Button are pictured in their grocery and meat market once located on Main Street in the village. (Courtesy of Jean B. Lang Western New York Historical Collection.)

Once located in Alfred Station behind the present shop of the Bicycle Man, this was the home of the village cooper, Isaac Lewis. The photograph was taken in the early 1870s. (Courtesy of Baker's Bridge Association.)

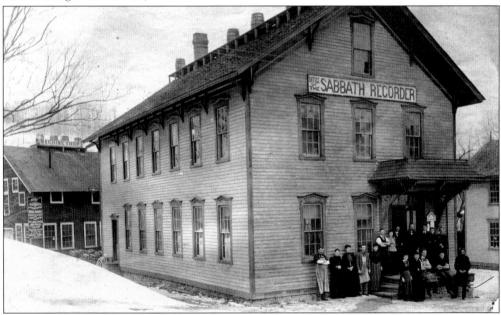

Located on Main Street (next to the present-day post office), the Sabbath Recorder Printing Office, in the foreground, printed many publications for the university, community, and Seventh Day Baptist denomination. Rogers Machine Shop is in the background. Posing for the photograph in 1893 are, from left to right, (first row) unidentified, Elizabeth Whitford, unidentified, Frank Whitford, and ? Bennehoff; (second row) L. Niles, Alice Sisson Greene, Lucy King Clark, Frank A. Crumb, Mae Davis Truman, unidentified, Edith P. Davis, L. A. Platts, and four unidentified people. (Courtesy of G. Douglas Clarke.)

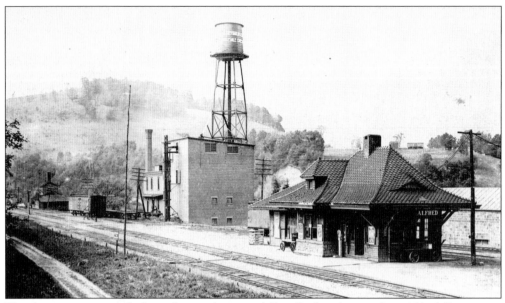

The first train to travel along the newly opened Erie Railroad arrived in Alfred Station on May 15, 1851. It carried Pres. Millard Fillmore and Secretary of State Daniel Webster, who rode the excursion train celebrating the opening of the line. The fare to travel from Alfred Station to Hornell that year was 30¢. This depot was constructed shortly after the original one burned down in April 1895. (Courtesy of Baker's Bridge Association.)

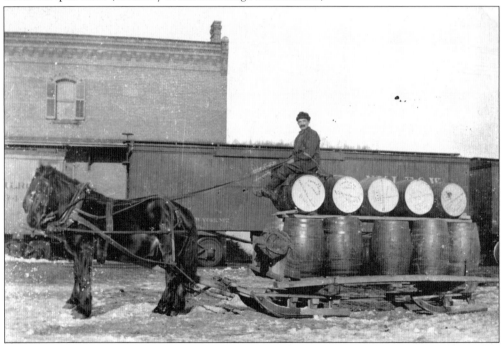

Transportation of goods to and from Alfred was greatly facilitated by the Erie Railroad. This played a major role in the economic growth of the area. The barrels are labeled with the names Crandall, Rosebush, and Armstrong, all businessmen in the village. (Courtesy of Baker's Bridge Association.)

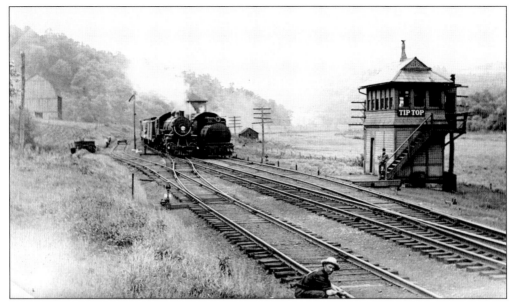

At 1,783 feet above sea level, Tip Top, as a section along Route 21 between Andover and Alfred Station is known, is the highest point between New York and Chicago on what was originally the Erie Railroad. A water tower, telegraph tower, and switching station were all once located here for the steam engines, which often found it hard to make the steep grade. Gerald Cartwright is in the foreground of this 1920s photograph. (Courtesy of Baker's Bridge Association.)

"The Big Chicken," which stands in front of Robert and Shirley Tomm's house on Route 21, is a local landmark. In 1952, the Tomms purchased the Cy Rennells farm at Tip Top and moved there four years later to begin their poultry farm. Local residents have been stopping by to purchase eggs from them ever since. (Courtesy of the Tomm family.)

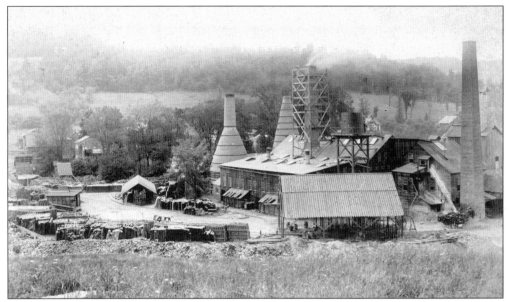

Located on North Main Street, the Celadon Terra Cotta Company was organized in 1888 after it was discovered that the local clay could be used to produce quality terra-cotta tiles. The clay from the nearby Kanakadea Creek produced a green tile known to artists as celadon green. When that clay supply dwindled, products were produced using shale from Alfred Station that fired to the better-known reddish color. (Courtesy of Jean B. Lang Western New York Historical Collection.)

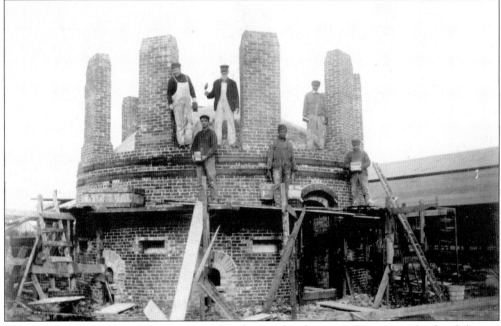

The Celadon Terra Cotta Company employed many local men and women. The first kiln was constructed in 1889, and firing of products began soon after. Additional kilns were added as the company grew. The company initially manufactured bricks and roofing tiles but later expanded into decorative pieces as well. (Courtesy of Peggy and Dan Rase.)

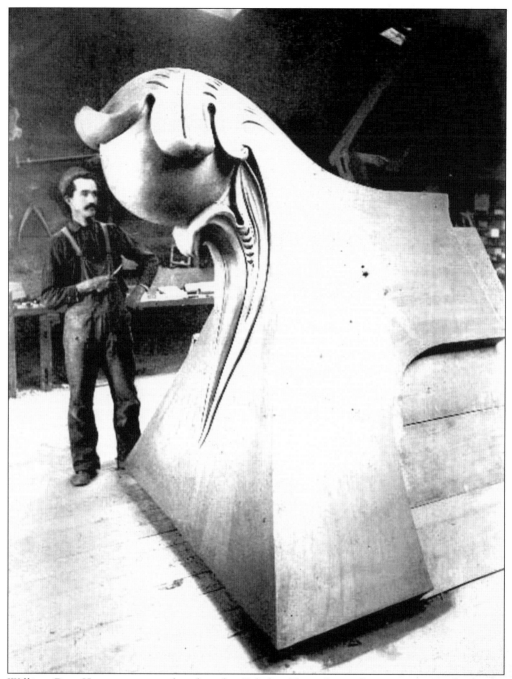

William Burt Kenyon was employed at the Celadon Terra Cotta Company as a sculptor who carved and cast statues, figurines, decorations, and tiles. The finished products were loaded onto wagons and transferred to the train depot in Alfred Station for delivery. After the tile plant burned in 1909, Kenyon was sent to Chicago and then Coffeeville, Kansas. (Courtesy of Dick Green.)

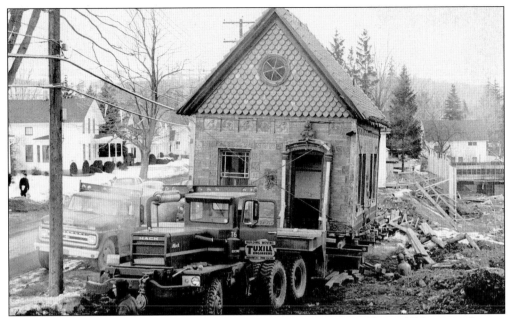

When Alfred University began making plans to construct its McLane Physical Education Center, a group of residents formed the Alfred Historical Society in 1967 to preserve and restore the Celadon Terra Cotta building. It raised funds and eventually moved the building to its present location at the intersection of Main and Pine Streets. It is seen here in 1970 being transported from its original site. (Courtesy of Jean B. Lang Western New York Historical Collection.)

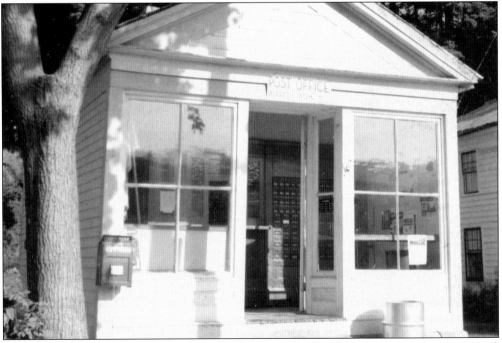

Now the home of Hillbottom Pottery in Alfred Station, this building (constructed prior to 1869) has been home to a jewelry store, barbershop, and the Alfred Station post office, pictured here in the late 1950s. (Courtesy of Baker's Bridge Association.)

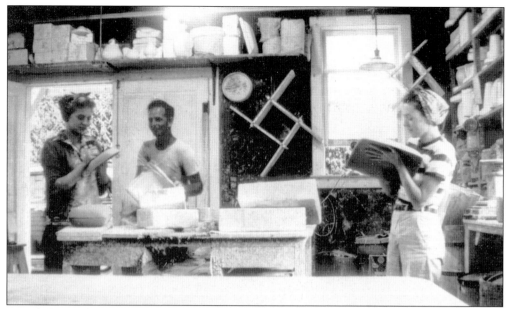

From left to right, Thelma Burdick Palmiter, William Palmer, and Vesta Clare Palmer work on pieces at the Glidden factory in the early 1940s. (Courtesy of Alfred Historical Society.)

Glidden Pottery, named for its owner and designer, Glidden Parker, operated as a manufacturing company on North Main Street in Alfred from 1940 through 1958. Glidden ware, mostly hand-decorated, functional dinnerware, is now a collector's item. This photograph of the plant, taken on July 15, 1959, was taken after the company shut down. (Courtesy of Alfred University Archives.)

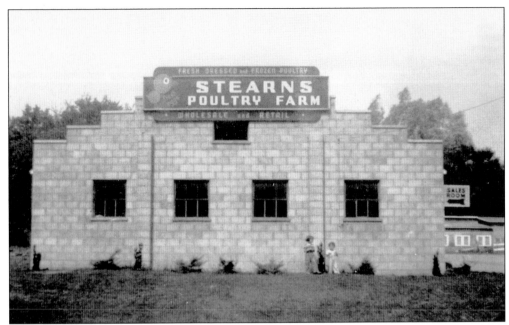

Stearns Poultry Farm was created in 1937 by Judson Stearns as a way to pay his tuition at Alfred University. In 1941, he moved his operation from Hartsville Hill to its present site on Route 244. After graduation, Stearns decided to continue with the growing business instead of becoming a teacher. His processing plant and two of his children, Linda (left) and Patricia, are seen here in 1954. (Courtesy of the Stearns family.)

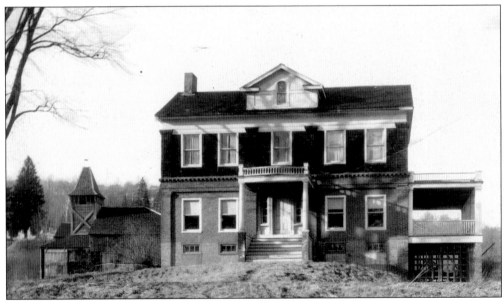

This house (owned by the Stearns family) between Alfred and Alfred Station is believed to be on the site of Edward Green's home, built shortly after he arrived in 1807. When his grandson Lorenzo Green lived in the house it was a one-story brick house. It was later enlarged, becoming a two-story structure, around 1911, when owned by Henry Moore. (Courtesy of the Stearns family.)

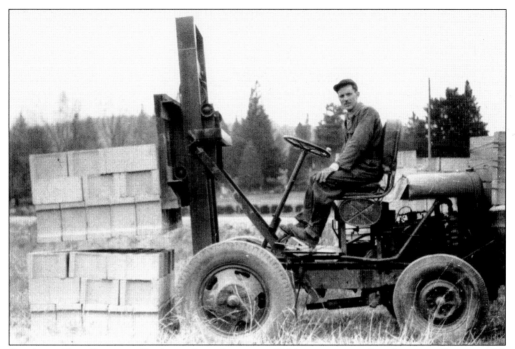

Southern Tier Concrete Products, Inc., began in 1946 as a partnership between Benjamin H. Palmer Sr. and Benjamin H. Palmer Jr. (seen here in 1948). In 1959, its plant on Route 244 became the first fully automated block plant in New York State. By the end of 2006, the plant had produced over 55 million units. (Courtesy of Jean B. Lang Western New York Historical Collection.)

The Alfred Atlas Gravel and Sand Corporation formed in 1928 when John Jake Merrill, D. Sherman Burdick, Ray W. Wingate, and James T. Foody purchased the small sand and gravel bank operated by Leonard Claire. Some of its equipment is shown here in the 1940s digging on Route 244, across from Alfred Station's post office and fire hall. (Courtesy of Baker's Bridge Association.)

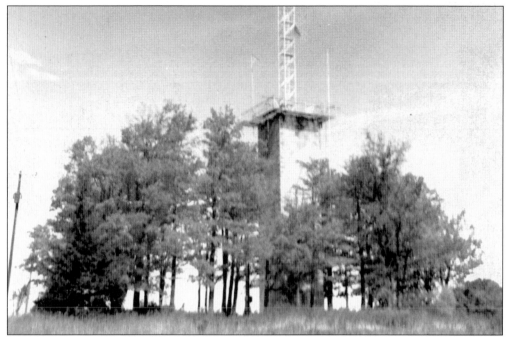

Due to his prior experimentation with the technology, Matthew Burzycki was asked by the village board in 1957 to help improve Alfred's television reception and options. Through his efforts, this 55-foot tower, with its 20-foot-tall antennas, was constructed at the top of Route 244, marking the beginning of the Alfred Cable Company, which was operated by the Burzycki family from September 1959 through 2001. (Courtesy of Gwen Burzycki.)

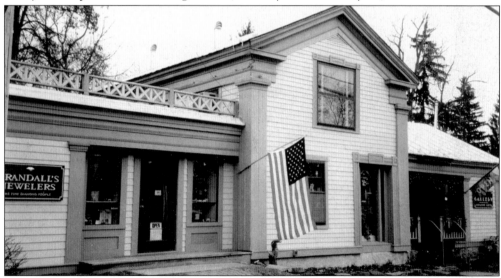

Built as a home in the 1830s, this building was used by Darwin Maxson, an abolitionist, as a station on the Underground Railroad. In 1955, Glidden Parker purchased it as a gallery and gift shop for his locally made pottery. By 1979, it was owned and operated by Faith D. Palmer as the Gallery gift shop. Space for Crandall's Jewelers, owned by James G. Palmer and originally located across the street, was added on in 1990. (Courtesy of Jean B. Lang Western New York Historical Collection.)

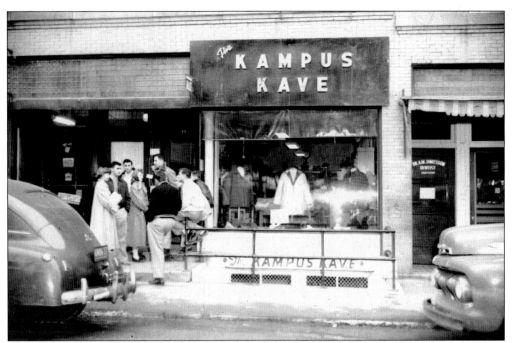

The Kampus Kave has been a fixture on the village's Main Street since it was opened by Al Rawady in September 1946. Originally located below street level, it moved to its present location in 1951, when the former occupant, the post office, relocated. This photograph was taken soon after the move. (Courtesy of Alfred University Archives.)

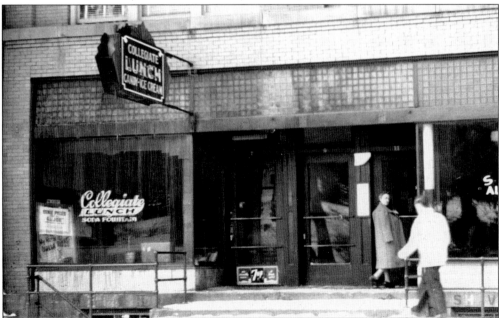

The Collegiate restaurant has been so named since 1924 and has been operated by the Ninos family since 1950. Customers enjoy the home-cooked meals and welcoming atmosphere as they eat among the plethora of fraternity and sorority paddles adorning the walls. (Courtesy of Marc Rawady.)

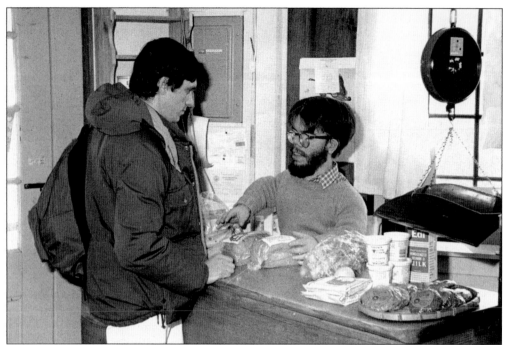

Located on the corner of Mill and West University Streets, Kinfolk, a natural foods store, has been owned and operated by Jessen and Elliott Case since May 1981. Elliott (right) is helping an unidentified customer at the store in April 1982. (Courtesy of Alfred University Archives.)

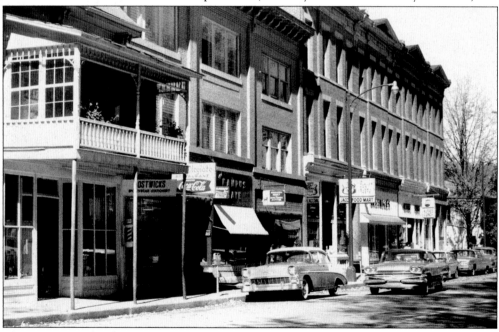

The 1950s was a bustling time in downtown Alfred for family-owned businesses, two of which continue to operate in the same location: the Collegiate restaurant and the Kampus Kave. More recent zoning regulations have outlawed the signposts hanging perpendicular to the buildings. (Courtesy of Jean B. Lang Western New York Historical Collection.)

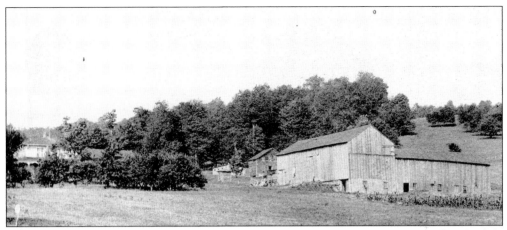

In the 1880s, Isaac Langworthy and his family lived in the small house (center, above) while building the 19-room house on the left. In 1929, Ernest and Ferne Jacox Snyder moved to Edgewood Farm with a few cows, a team of horses, and a lot of hope, only to lose everything to a fire in 1931. They rebuilt the next year, losing the barn once more to a fire in December 1939. With determination, they rebuilt yet again the following summer with the help of family and friends. In 1956, Ernest's son Harold and his wife, Bev, moved into the house, ran the dairy farm for 38 years, and raised four daughters. Edgewood Farm, seen below in 1977, is a classic example of farms in the Alfred area. High Street can be seen above the pond. (Courtesy of Harold Snyder.)

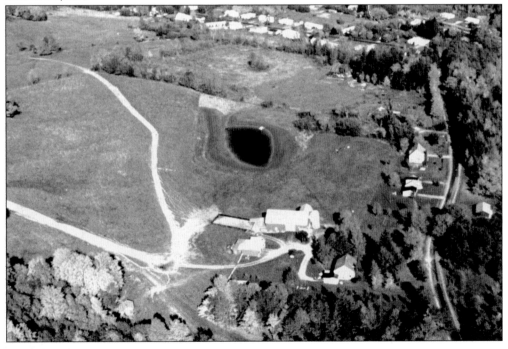

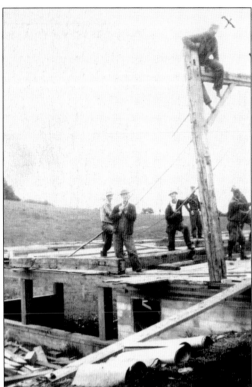

After his barn burned in 1939, Ernest Snyder purchased and moved a barn from Vandermark Road to his farm on Randolph Road. With assistance from friends and family, a barn-raising bee was held in 1940. The heavy beams were assembled flat with wooden pegs and then raised by hand, using spike poles to stand them vertically. (Courtesy of Harold Snyder.)

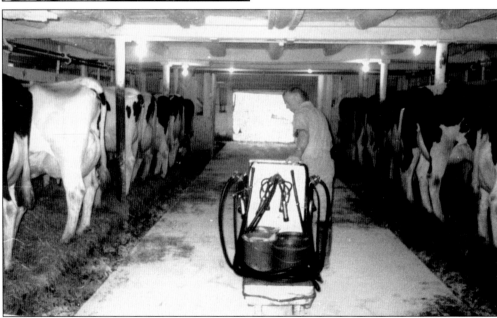

The dairy industry played an important role in Alfred's history. Through the 1930s milking was done by hand. That changed in the 1940s when pail milking machines became available. By the 1970s, Harold Snyder, seen here in his barn on Randolph Road, was using a pipeline system that carried the milk directly to stainless steel storage tanks in the milk house. (Courtesy of Harold Snyder.)

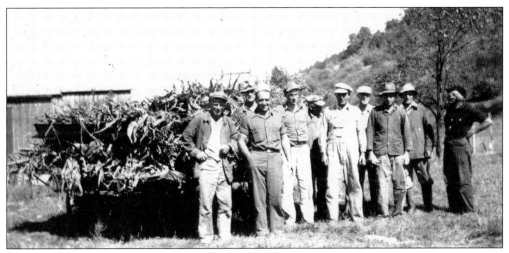

A corn-cutting crew poses in 1943 or 1944 at the Agnes and Charles Eldon Woodruff farm in Alfred Station. From left to right are Ross Champlin, William P. Woodruff, Clinton Burdick, Dale Woodruff, Jay Trimm or Delfrey Ormsby, Charles Eldon Woodruff, Fred Pierce, possibly Milford Clark, Robert Ormsby, and possibly Cecil Orvis. (Courtesy of Baker's Bridge Association.)

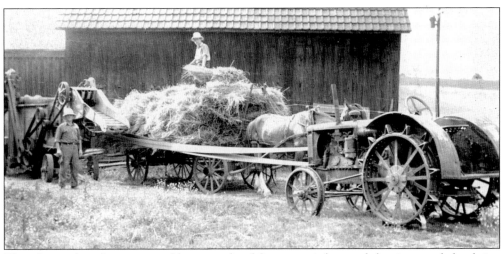

The advent of machinery was a blessing to local farmers as it lessened the time needed to bring in the crops as well as reduced the number of hands necessary to finish the job. These men are threshing wheat in 1940 on the Cleon Ells farm in Alfred Station, at the intersection of Pleasant Valley and Hamilton Hill Roads. Ells is standing on the left. (Courtesy of Baker's Bridge Association.)

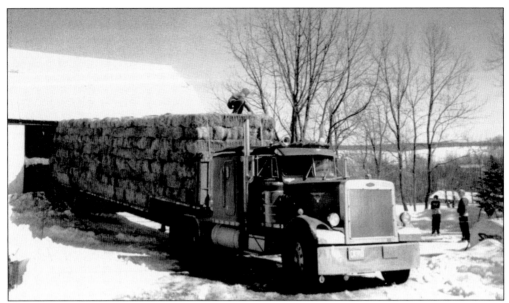

Many local farmers are able to produce more than they require for their own needs, as is illustrated by this load of 800 bales being prepared for sale at Edgewood Farm on Randolph Road. (Courtesy of Harold Snyder.)

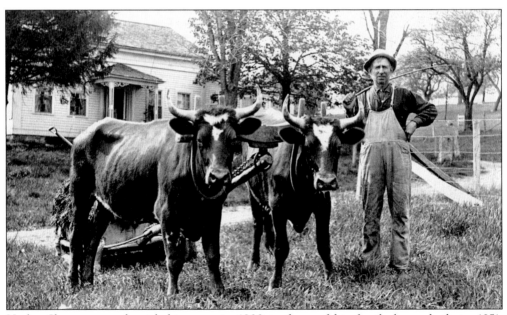

Harley Sherman stands with his oxen in 1900 in front of his family home built in 1851. Located on Sherman Road, Evergreen Farm had an excellent reputation due to Sherman's diligence and interest in agriculture. Best known for his sheep, he also raised pigs and other standard farm animals, maintained fruit orchards, and made maple syrup. (Courtesy of Baker's Bridge Association.)

Two

SEEN AROUND TOWN

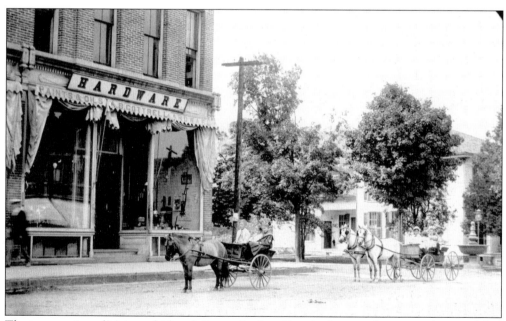

The intersection of Main and Church Streets in the village looks quite the same today as it did in 1906. The hardware store is currently a Chinese restaurant. The W. H. Bassett house, once the offices of the Alfred Telephone and Telegraph Company (founded in 1897), is now the Union University Church Center. The water fountain was installed in August 1906 under the direction of the Women's Christian Temperance Union. (Courtesy of Alfred Historical Society.)

The "event of the season" in November 1907 was a dinner given by the men of Alfred as a fund-raiser for the newly constructed Seventh Day Baptist Parish House. These local boys (above) advertised the event with the help of their pony. The dinner program began with a parade around the village, culminating with a Chinese dinner in a dining room decorated with lanterns, banners, and other Oriental touches. The men shown below in costume served as waiters for the dinner. From left to right are (first row, sitting on floor) O. P. Fairfield, possibly D. S. Barnsworth, E. W. Place, F. S. Truman, G. A. Place, D. S. Bassett, possibly J. S. Sisson, and W. S. Maxson; (second row) H. C. Whitford, D. D. Randolph, D. H. Rogers, F. L. Greene, T. Stephen, W. H. Bassett, W. B. Kenyon, W. F. Burdick, F. L. Burdick, L. Bennehoff, and E. W. Ayres; (third row) O. C. Greene, W. W. Coon, possibly F. S. Pener, G. Stillman, F. A. Crumb, ? Webster, F. A. Langworthy, A. B. Kenyon, V. A. Baggs, ? Armstrong, N. Annas, and W. H. Crandall; (fourth row) J. C. Potter, A. A. Burdick, E. E. Hamilton, possibly F. S. Pener, L. S. Beyea, G. C. Burdick, F. H. Ellis, J. Randolph, C. Gamble, M. Sheppard, and ? Farley. (Courtesy of Peggy and Dan Rase.)

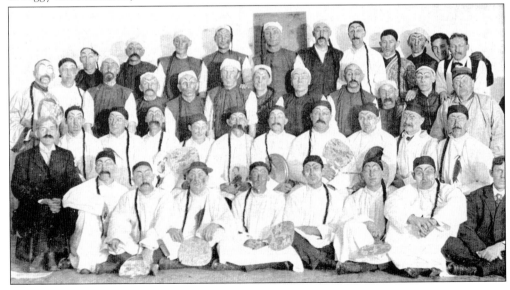

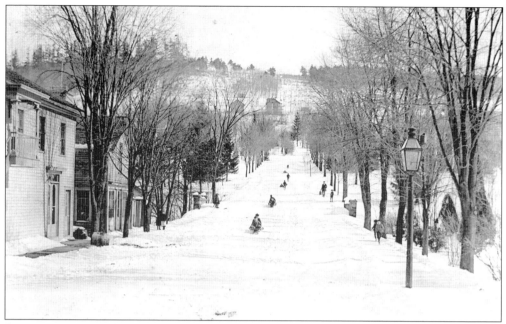

Coasting was a popular winter recreation for local children and university students. This track, coming down from the university on what was called Chapel Hill, was used extensively; when it was well covered with snow, the sleds could travel over three-quarters of a mile. Kerosene lamps were installed in the village in 1889. The general store on the left burned down in 1913. Behind it is a steam laundry. (Courtesy of Peggy and Dan Rase.)

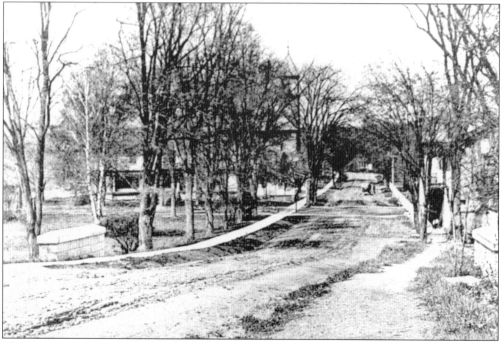

Those interested in coasting or sledding down the popular route in winter would see this view, around 1900, as their sleds raced down University Street. (Courtesy of Stacy Pierce.)

Perhaps these children are dressed for a church or school play. Agnes Kenyon Clarke Bond, born in 1886, is the center girl in the back row. (Courtesy of G. Douglas Clarke.)

This photograph shows an unknown group of girls in front of the Adelaide (Addie) Sheldon house at 109 North Main Street. (Courtesy of G. Douglas Clarke.)

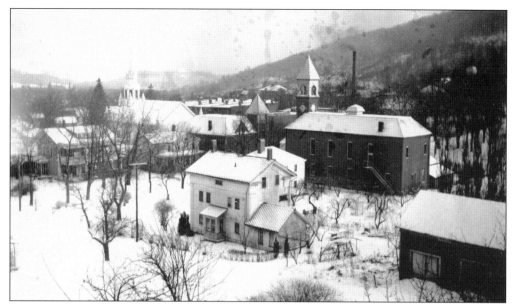

"Four spires in a row" could be this photograph's title, as it shows the Seventh Day Baptist church (1854), the church's Parish House (1906), the Firemen's Hall (1890), and the university heating plant's smokestack (1918). Located to the left of the Parish House, and now the site of a parking lot, is a house once owned by Daisy Clarke. The house to the left of that is now an Alfred State College fraternity. (Courtesy of Peggy and Dan Rase.)

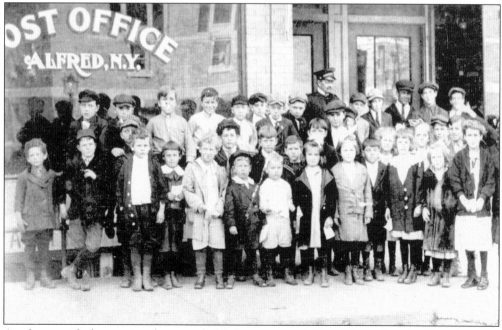

Any boy or girl who presented a properly filled-out coupon (clipped from the *Alfred Sun*) between 3:45 p.m. and 5:45 p.m. on May 4, 1916, received a free bag of marbles from W. H. Crandall's insurance company. Shown here are the enterprising youngsters who took advantage of the offer. (Courtesy of Jean B. Lang Western New York Historical Collection.)

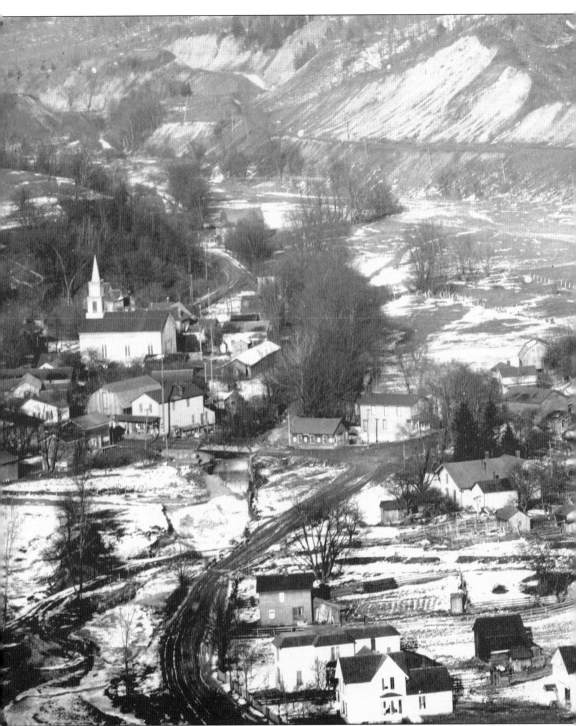

This is a view, looking north, of Alfred Station around 1910. The roof tile and brick factory is located on the right with the Erie depot just above. Baker's Bridge, the original name of Alfred Station, was well situated since it was close to the railroad and along the heavily traveled route between Andover and Hornell. During its early years, it was home to many different businesses:

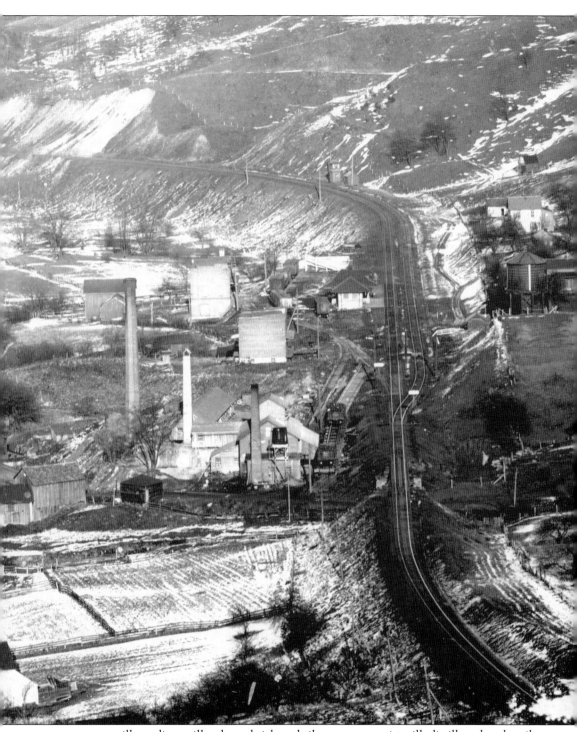

a tannery, sawmill, carding mill, ashery, brick and tile company, gristmill, distillery, hotel, pail factory, feed store, cooper shop, barbershop, grocery and general mercantile, and a variety of others. (Courtesy of Baker's Bridge Association.)

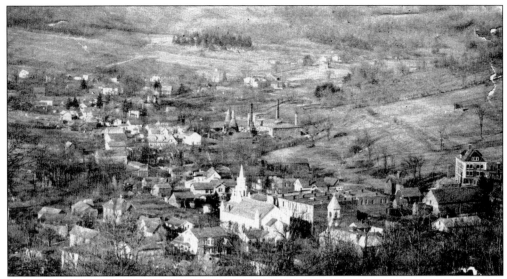

Looking north in 1901, this photograph does a nice job of showing the cluster of village buildings as well as the Celadon Terra Cotta Company tile plant surrounded by what were once open fields. (Courtesy of Alfred University Archives.)

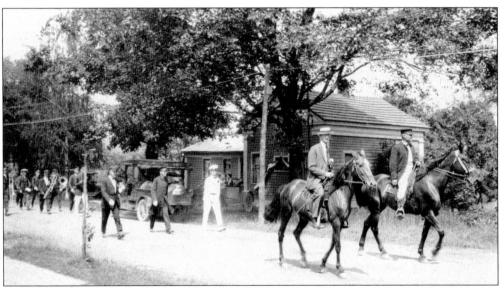

John Jake Merrill, on the left horse, is leading a 1920s parade on North Main Street. They are most likely returning from a Memorial Day observance at the Alfred Rural Cemetery. Merrill, one of the founders of the Celadon Terra Cotta Company is well remembered for his work with the College of Ceramics and Alfred University. The house in the background was moved to Palmiter Road in 1984. (Courtesy of Peggy and Dan Rase.)

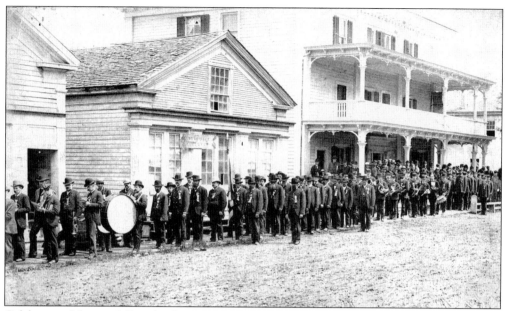

Celebrating Memorial Day (or Decoration Day, as it was originally called) was important to the Alfred community as evidenced in this mid-1880s photograph showing parade participants lining up in front of the Burdick Hotel on the village's Main Street. The hotel and the buildings to the left were all destroyed by fire in 1887. (Courtesy of Jean B. Lang Western New York Historical Collection.)

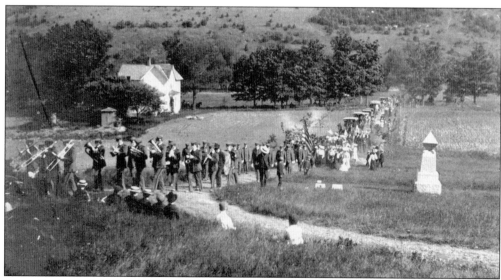

Typically the early Memorial Day observances in Alfred started with a church program followed by a procession to the cemetery where the graves of local soldiers were decorated. The Alfred Rural Cemetery Association was created in 1847. A well was drilled in 1897 to provide water for flowers and for the horses who brought visitors. (Courtesy of Baker's Bridge Association.)

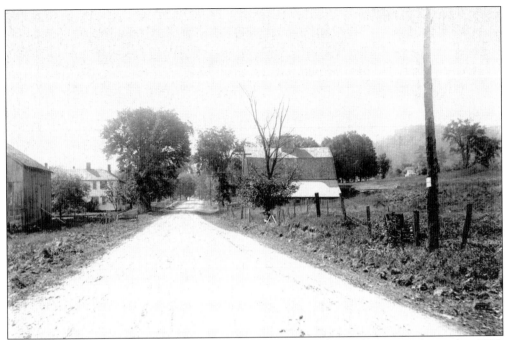

It was a dusty ride from Alfred Station into the village before the road was macadamized in 1895. On the way, travelers passed by the Stillman farm and house. Built in 1815, it is currently an apartment house. (Courtesy of Jean B. Lang Western New York Historical Collection.)

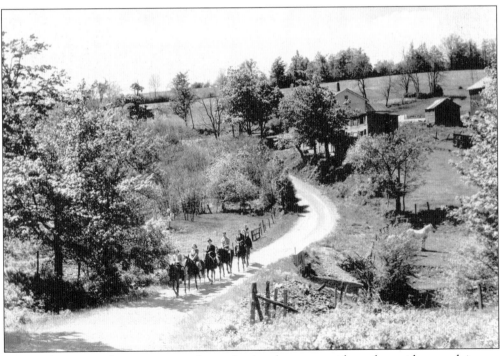

Horse riding was a pleasant way to relax and enjoy the countryside as these riders are doing on Waterwells Road. (Courtesy of Jean B. Lang Western New York Historical Collection.)

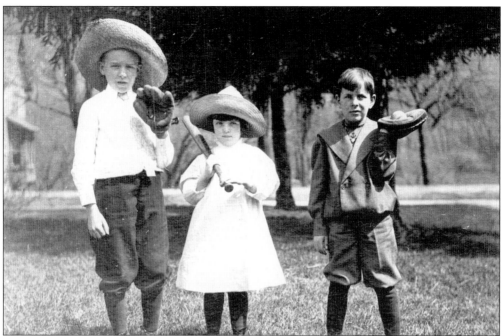

Baseball was a popular game for boys and girls, young and old. Ruth Whitford (later Russell) stands with two unidentified boys. (Courtesy of Jean B. Lang Western New York Historical Collection.)

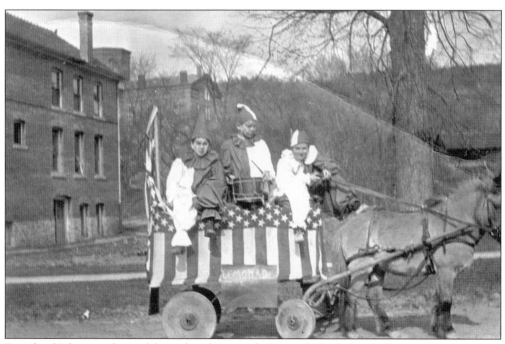

Fourth of July was often celebrated with a parade (around 1906), baseball game, band concert, and fireworks display. The Sun Publishing Company headquarters and the university women's residence hall, the Brick, are in the background. (Courtesy of Jean B. Lang Western New York Historical Collection.)

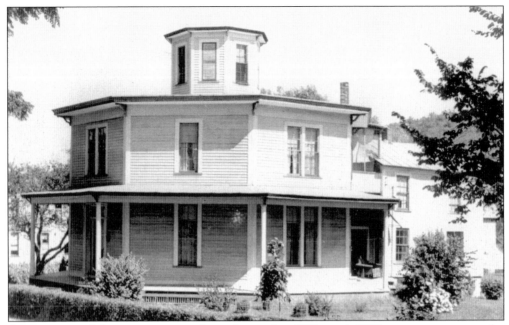

Since octagonal houses were popular only in the 1850s and 1860s, not many examples remain. One of the earliest, constructed around 1850, still stands at 57 South Main Street as a reminder of this unusual architectural style. (Courtesy of Jean B. Lang Western New York Historical Collection.)

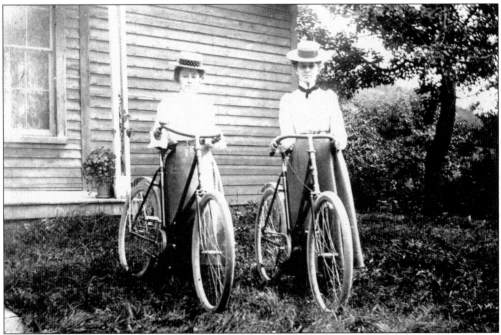

Bicycle riding was a popular recreation by the end of the 19th century. Amelia (Millie) Fenner, left, and her older sister, Acenath (Senie) Fenner, are ready to go for a ride. They were daughters of Elisha Potter Fenner, a local cheese maker who, at one time, owned four cheese factories in town. (Courtesy of Jean B. Lang Western New York Historical Collection.)

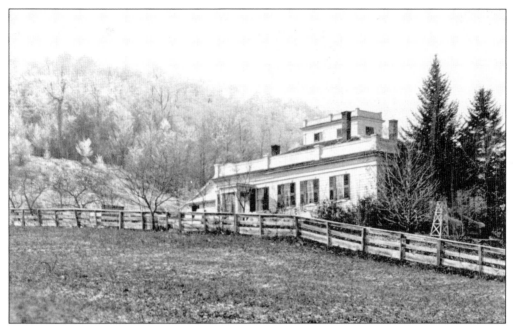

This unusual Greek Revival house at 25 West University Street was constructed around 1830–1847 and was for many years the home of Nathan Vars Hull, pastor of the Alfred Seventh Day Baptist Church and president of the university board of trustees. The subsequent owner was Calvin D. Reynolds, owner of a prominent cheese factory in town. (Courtesy of G. Douglas Clarke.)

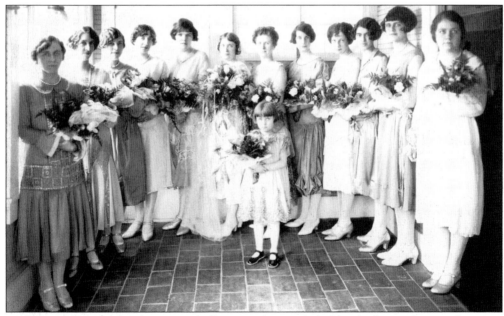

Anna Merrill married Robert Campbell on April 6, 1926, and her bridesmaids wore their very best dresses for the wedding. From left to right are Elizabeth Robie, Evelyn Campbell, Jewel Campbell, Alice Philbrick, Ruth Whitford, Anna Merrill (bride), Margaret Merrill Wingate, Mary Irish, Mabel Fenner, Jeannette Randolph, Hazel Stevens, and Helen Thomas. Margaret (Peggy) Wingate is the flower girl. (Courtesy of Jean B. Lang Western New York Historical Collection.)

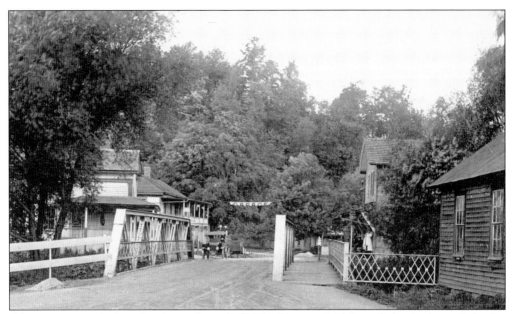

After arriving with their families in June 1807, Thaddeus and Alpheus Baker built a pole bridge across the creek in order to continue their travel on to Andover. Unintentionally they gave Alfred Station its first name: Baker's Bridge. (Courtesy of Baker's Bridge Association.)

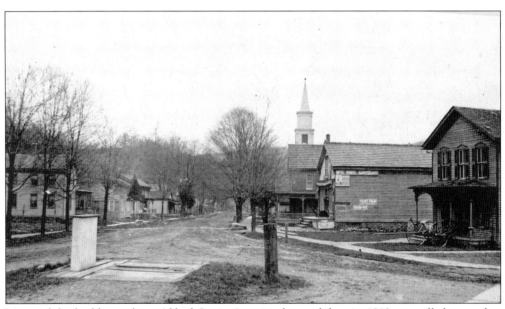

Many of the buildings along Alfred Station's main thoroughfare in 1910 are still there today. The scales in the foreground were used to weigh sand and gravel as well as products being shipped by rail. (Courtesy of Baker's Bridge Association.)

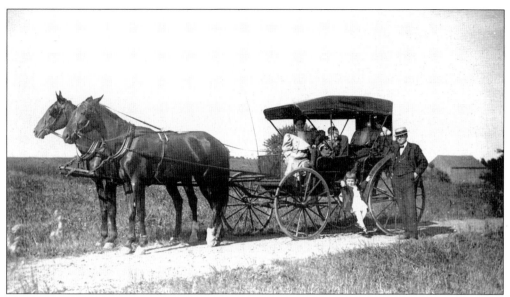

Elizabeth West Whitford, her son Alfred West "Bill" Whitford, daughter Ruth Dare Whitford (later Russell), and husband, Frank Whitford, are out for a ride in the fall of 1906. (Courtesy of Jean B. Lang Western New York Historical Collection.)

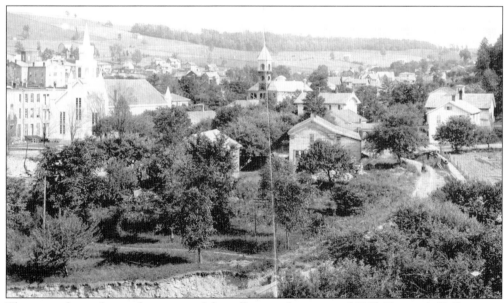

This view shows the southern part of the village in the spring of 1891. Firemen's Hall, center, is almost completed, and the hillside is still open farmland. (Courtesy of Jean B. Lang Western New York Historical Collection.)

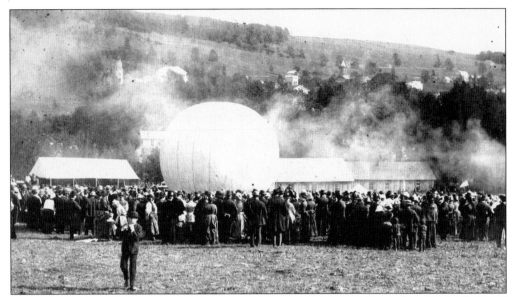

This hot-air balloon must have been the talk of the town after it was featured at the third annual fair hosted by the Canacadea Agricultural Association of Alfred Centre in 1886. (Courtesy of Alfred University Archives.)

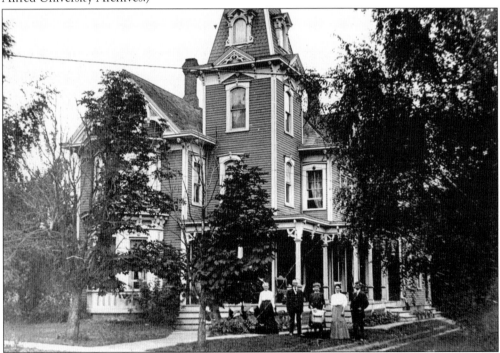

This Italianate house at 56 West University Street was built by Albert B. Sherman around 1864. Standing in front of their house in 1906 are Thankful Melissa "Minnie" Bloss Reynolds and her husband, James Lester Reynolds. Their grandson in the carriage, Lester Eugene Reynolds, is being supported by an unknown woman. Lester's parents, Mabel Foster Reynolds (Alfred's first female postmistress) and Edwin Orlando Reynolds, are on the right. (Courtesy of Alfred University Archives.)

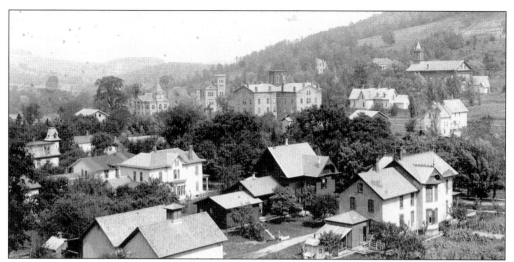

"Nestled in the trees" is one way to describe the village in the late 1890s. The Alfred University campus can be seen in the upper half of the photograph while houses along South Main Street display their interesting features along the lower half. (Courtesy of Alfred University Archives.)

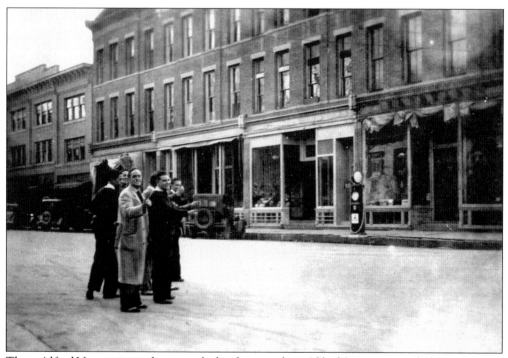

These Alfred University students may be hitching a ride to Alfred Station to catch the train in the 1930s, or perhaps they are just showing off for the camera! In any case, their view of the village's Main Street is remarkably similar to the one today. (Courtesy of Alfred University Archives.)

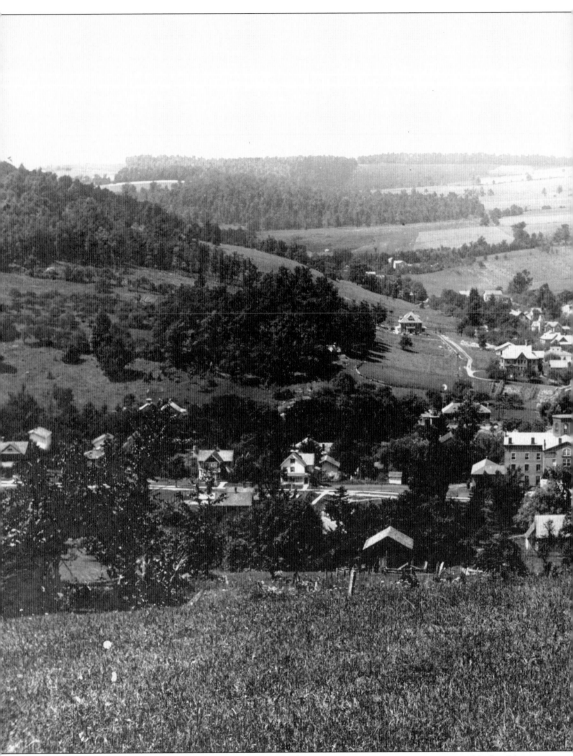

Looking west over the village, around 1905, it is heartening to see many recognizable buildings. It really illustrates that many homes and other structures have been part of Alfred's fabric for

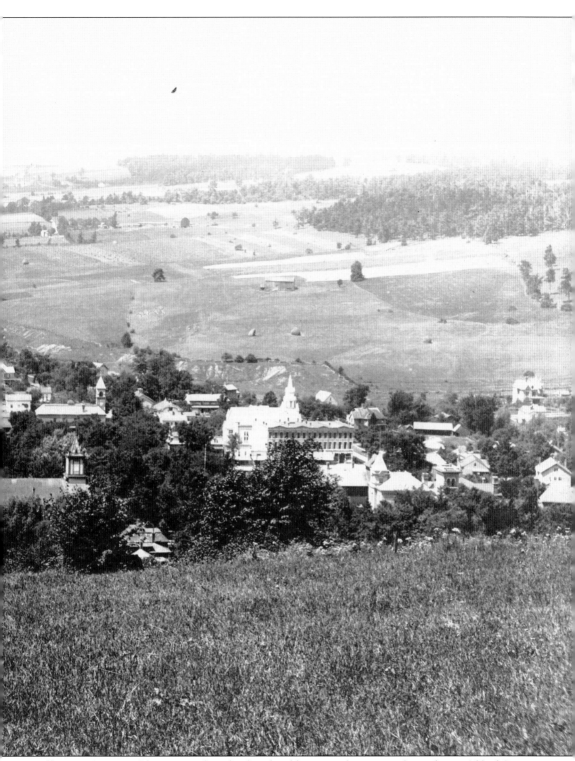

well over a century. Also notice that the farmland has since been transformed into Alfred State College. (Courtesy of Alfred University Archives.)

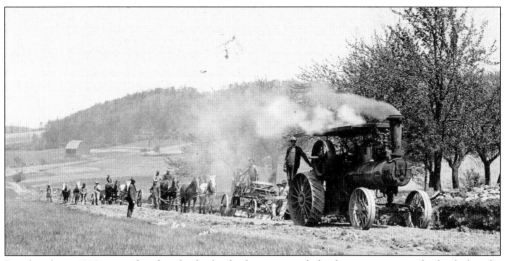

Roadwork in 1910 was a hard task, for both the men and the horses, even with the help of a steam-powered tractor. This shows work on the road in the vicinity of Tip Top (along Route 21 between Alfred Station and Andover). (Courtesy of Baker's Bridge Association.)

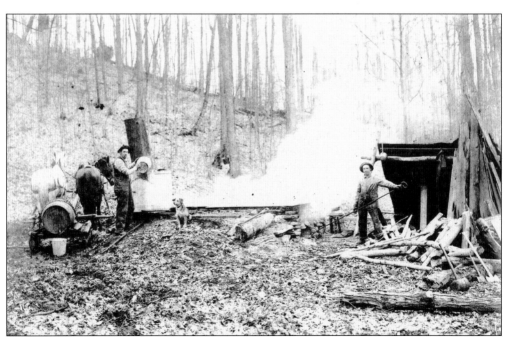

Producing maple sugar and syrup is a long-standing tradition in Alfred. Delfrey Ormsby, left, and Orson Ormsby are boiling sap at Delfrey's farm sometime before World War I (Orson was killed during that war). The farm was located on Whitford Road. (Courtesy of Clinton Ormsby.)

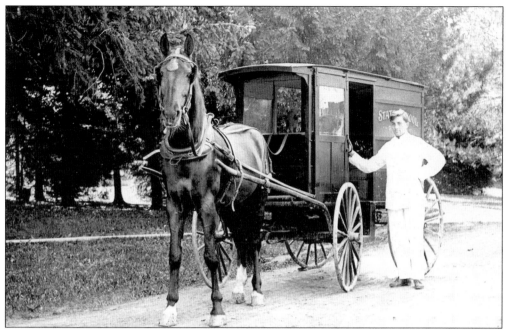

Local residents took delivery of their milk, produced at the School of Agriculture farm, from this horse-drawn wagon, shown in 1910. A quart of buttermilk was 5¢ that year. (Courtesy of Peggy and Dan Rase.)

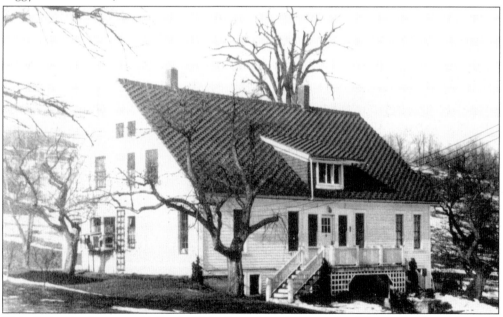

This distinctive house at 74 South Main Street was home to the Watson family in the early to mid-20th century. Dr. Lloyd Watson was renowned for his work with artificial insemination of honeybees. His wife, Olive, is remembered as the inventor of delicious Honey Pot candy. Developed by her in 1915, using excess honey from her husband's experiments, the secret candy recipe has been handed down and is still handmade in Alfred. (Courtesy of Jean B. Lang Western New York Historical Collection.)

In September 1944, Charles Burdick (left) and his brother, Doug (second from left), worked with their neighbors the Close brothers to gather bags of milkweed pods, which were dried and sold to the U.S. Army during World War II for use in life jackets. (Courtesy of Baker's Bridge Association.)

Hazel Trimm, left, and Gretchen Burdick, shown in July 1942, were two of the many local volunteers who spent time at this building on Cook Road observing and reporting overhead airplanes during World War II. (Courtesy of Baker's Bridge Association.)

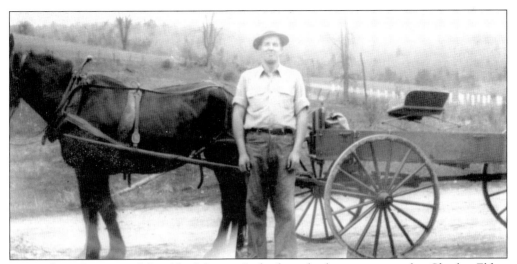

Rev. Albert Rogers and his blind horse, Lady, brought his wagon to the Charles Eldon Woodruff farm on Hartsville Hill in the 1940s to collect potatoes. (Courtesy of Baker's Bridge Association.)

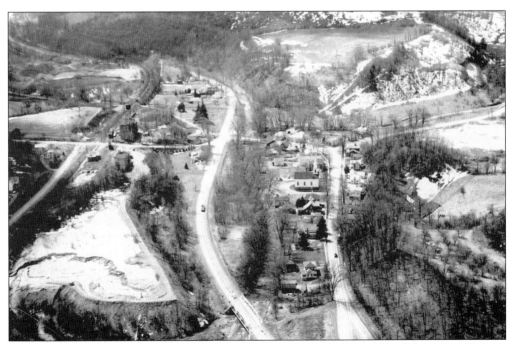

This excellent view, looking south, shows Alfred Station in the late 1950s. (Courtesy of Baker's Bridge Association.)

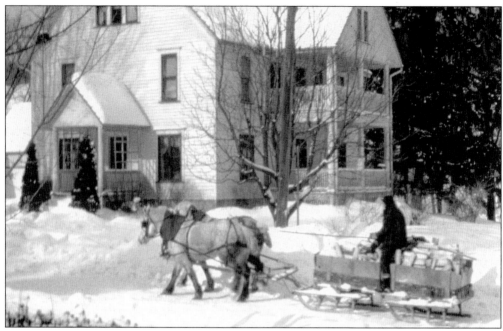

A load of firewood is passing by the Eleanor "Nell" and Rodney Sisson house in the 1950s, now the home of Café Za, on the corner of Church and Elm Streets. (Courtesy of G. Douglas Clarke.)

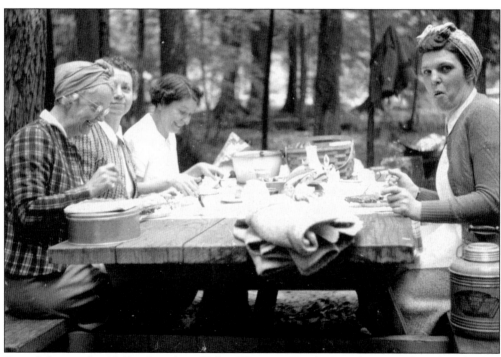

From left to right, Nellie Saunders, Helen Thomas, Hazel Humphreys, and Ruth Whitford Russell enjoy a 1930s picnic. Thomas and Humphreys were certainly both outdoors lovers as they were members of the Appalachian Hiking Club. (Courtesy of Jean B. Lang Western New York Historical Collection.)

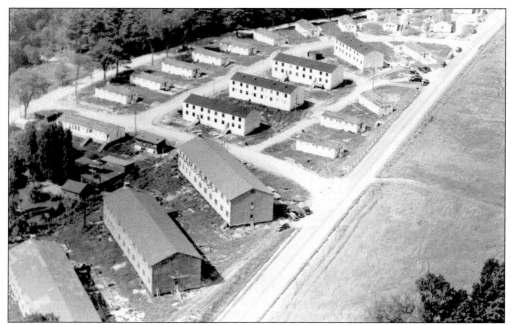

As servicemen returned to civilian life following World War II, many wished to complete their college education and needed appropriate housing for their wives and growing families. As a result, Saxon Heights, humorously known as Diaper Hill, was constructed on land between Glen Street and Route 244 in 1946. The units were demolished in the late 1960s. (Courtesy of Alfred University Archives.)

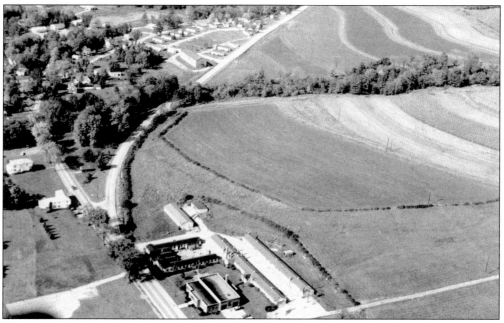

This aerial photograph, taken in the fall of 1967, offers a panoramic view of Route 244 as it turns toward Belmont. Located at the bottom are the Alfred State College agricultural engineering buildings. Near the top is Saxon Heights, or Diaper Hill, (now home to the Maple and Rose Apartments). (Courtesy of Alfred State College Archives.)

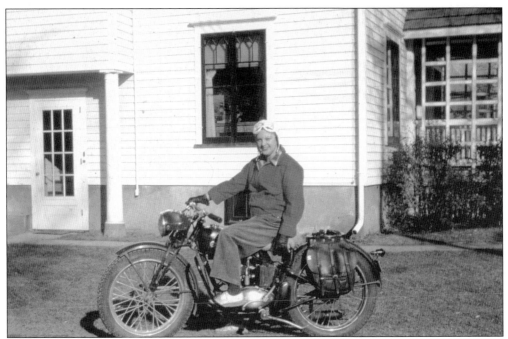

Not the typical 1950s woman, Eleanor "Nell" Sisson was proud of her motorcycle. (Courtesy of G. Douglas Clarke.)

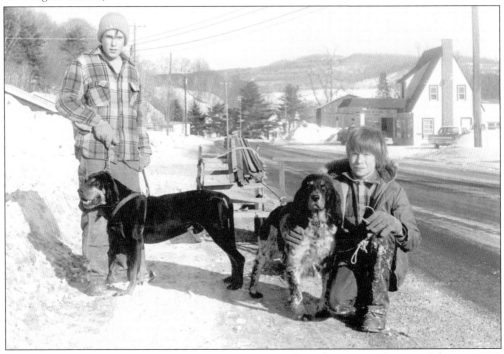

Vincent Aftuck (left) and Glenn Burdick are putting their dogs to good use in February 1979 along Route 244. The Alfred town building in the background, across from the motel, burned in July 1981, and a new structure for the town offices was built on Shaw Road in 1983. (Courtesy of Jean B. Lang Western New York Historical Collection.)

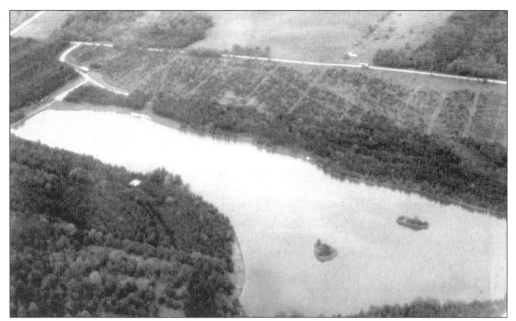

Located on Lake Road, Foster Lake was conceived and constructed by Eddy Foster in 1950. While many were skeptical of digging a 25-acre lake on top of a 2,260-foot hill with no stream to fill it, Foster remained optimistic. He proved his doubters wrong when the lake filled in four months. Originally designed as a nature preserve, it was used extensively by local families during the summers, as seen below in June 1974. Overseen for years by members of the Foster Lake Club, today it is owned and managed by Alfred University. (Courtesy of Sandy McGraw.)

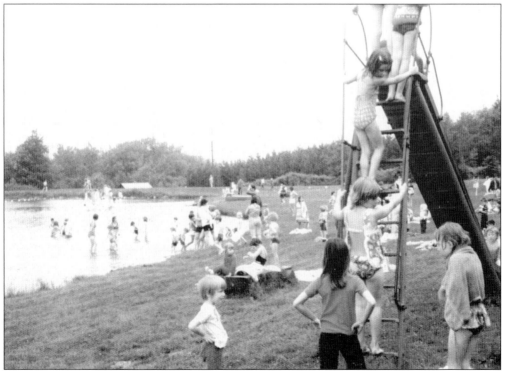

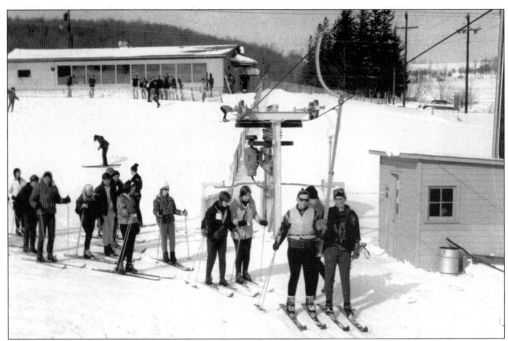

In 1965, the Alfred State College Student Association purchased a 30-acre hill on Route 244 (opposite the college's farm facility). To the delight of the local residents and students, Happy Valley opened in January 1966, after a ski slope was developed and a former stable converted into a ski lodge. In 1976, it was leased to the Martin Curran family, which operated it until 1981, when it closed permanently. (Courtesy Alfred State College Archives.)

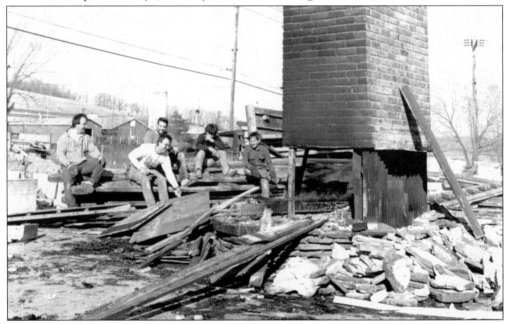

From left to right, Phil Curran, Pat Curran, Chris Curran, and two unidentified people are reminiscing in 1988 as they demolish the Happy Valley ski lodge. (Courtesy of Jean B. Lang Western New York Historical Collection.)

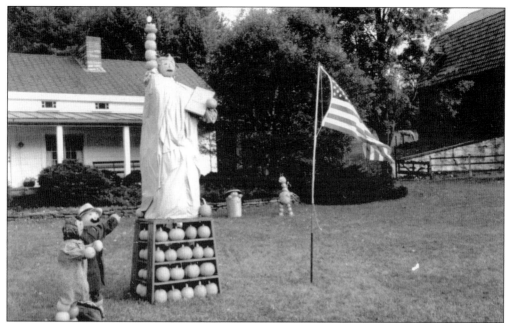

Between 1966 and 1991, local children waited anxiously for Halloween to see what display would be created from pumpkins at Lyle and Thelma Palmiter's pumpkin patch in Alfred Station. It became commonplace to see busloads of kids touring the patch as well as families stopping by to select their pumpkins for carving. The Statue of Liberty made its debut in 1986. (Courtesy of Lyle and Thelma Palmiter.)

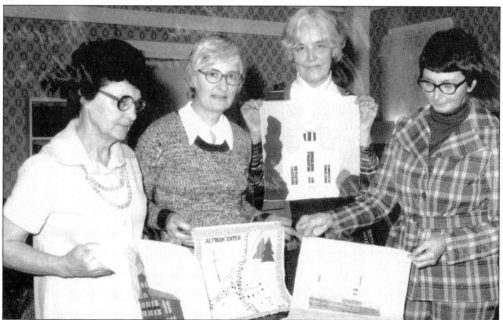

To celebrate the nation's 1976 bicentennial, the Alfred Historical Society organized the making of the Alfred Bicentennial Quilt. Each quilt block depicted a part of the town's history. Shown here with some examples are, from left to right, Margaret Klingensmith, June Brown, Nell Parry, and Jean Lang. (Courtesy of Jean B. Lang Western New York Historical Collection.)

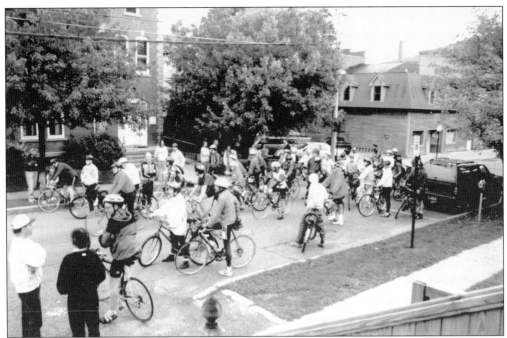

Waiting on West University Street are riders ready for the Century Bicycle Ride to begin. This event first took place on September 22, 1895, when 10 members of the Alfred Cycling Club rode a 100-mile route from Alfred to Olean and back. The ride was re-created in 1995 and repeated for many subsequent years. (Courtesy of Sandy McGraw.)

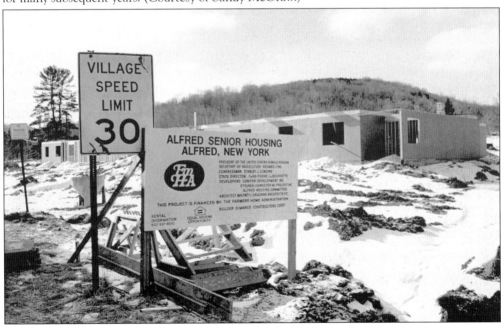

The Maple Apartments on Glen Street were opened in 1987. They were the result of the efforts of the Alfred Housing Committee, formed in 1979 by a group of local citizens who saw a need for affordable housing, particularly for the community's senior citizens and physically disabled. (Courtesy of Jean B. Lang Western New York Historical Collection.)

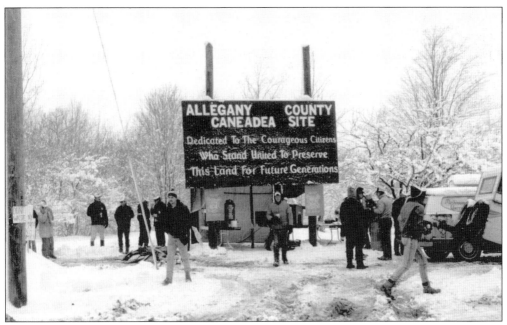

December 1988 marked the beginning of an important time in Allegany County. New York State had chosen three sites within the county as potential locations for a low-level radioactive waste storage facility. Over the next two years, citizens successfully rallied against the state to prevent this from happening. They developed a model of nonviolent grassroots protest involving civil disobedience that became well known throughout the country. The "Bump the Dump" fight, as it became known, affected numerous lives. Many people in Alfred were heavily involved with this action, and the orange Posted! No Dumping signs were prevalent throughout town. (Courtesy of Alfred University Archives.)

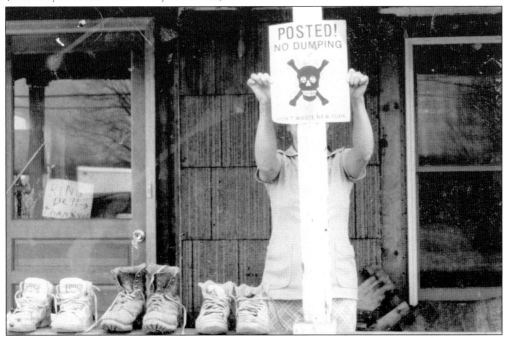

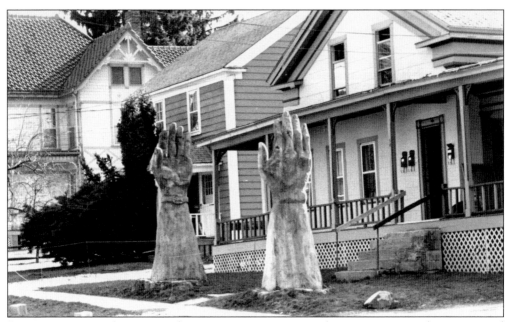

In a community with many resident artists, it is not unusual to see various sculptures around town, but this one was certainly unique. Needing to take down two large trees after the March 1991 ice storm, the owner decided to preserve their memory by having them carved into these outstretched hands. They remained a fun fixture at 54 South Main Street for almost a decade before they needed to be removed due to decay. (Courtesy of Alfred University Archives.)

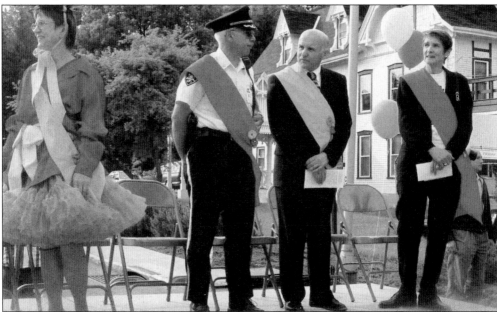

Not many towns would think twice about their traffic lights, but Alfred held a 30th birthday party for its one and only in June 2004. A parade was followed by an official ceremony featuring, from left to right, event co-organizer Hope Zaccagni, Allegany County sheriff Randal Belmont, Mayor William Hall, and former mayor Virginia Rasmussen. The event was later recognized in national newspapers. (Courtesy of Sandy McGraw.)

Three

EDUCATION

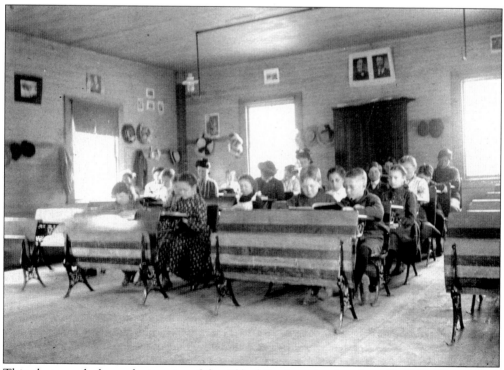

This photograph shows the interior of the Alfred Station school on June 12, 1903. (Courtesy of Baker's Bridge Association.)

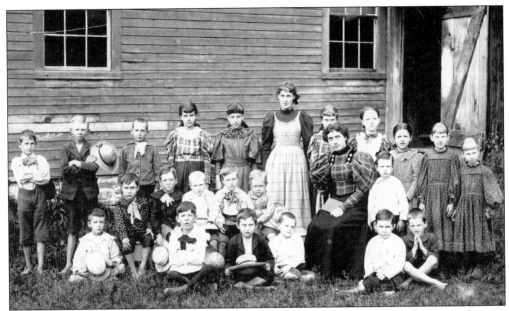

Students living in the Pleasant Valley area during the late 1800s attended the Goose Pasture School. From left to right are (first row) Fred Gavitt, Harley Goodwin, Ira Pierce, Rex Colegrove, and Ernest Pierce; (second row) Corwell Cook, Ralph Colegrove, Harry Austin, Everett Davis, Rex Lewis, Eldyn Champlin, Minnie Ready (teacher), and Arthur Ormsby; (third row) George Lewis, Archie Champlin, Earl Cook, Nellie Langworthy, Myrtle Gavitt, Edith Colegrove, Carrie Burdick, Bertha Pierce Palmiter, I. Lewis, Faith Odell, and Ruth Odell. (Courtesy of Baker's Bridge Association.)

Students living in the Railroad Valley/Tip Top area attended the Lanphear Valley School, shown here in 1912. The school building (now a house) and the barn are still standing along Route 21, just south of Kenyon Road. (Courtesy of Baker's Bridge Association.)

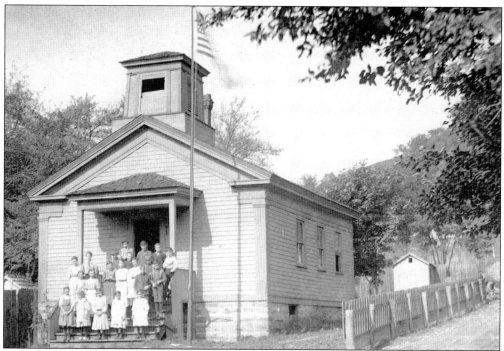

On June 16, 1907, students of the Alfred Station School, District No. 1 (presently the Bicycle Man shop), pose on the steps of their school, which was built in 1849. (Courtesy of Baker's Bridge Association.)

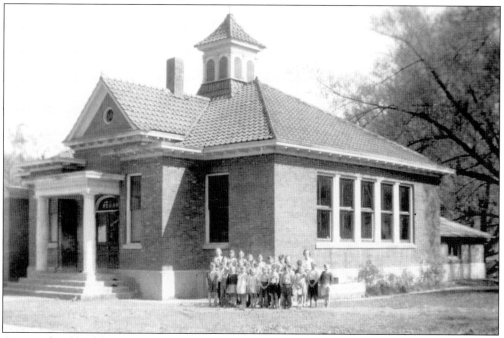

A new school building was constructed for Alfred Station in 1908 and is now that hamlet's post office and fire hall. (Courtesy of Baker's Bridge Association.)

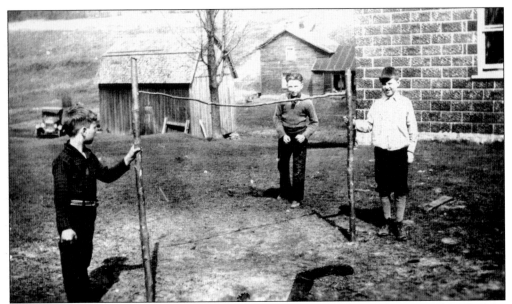

These boys are making good use of their recess at the East Valley school, commonly called the Red School House, located on the corner of East Valley Road and Burdick Hill Road. (Courtesy of Baker's Bridge Association.)

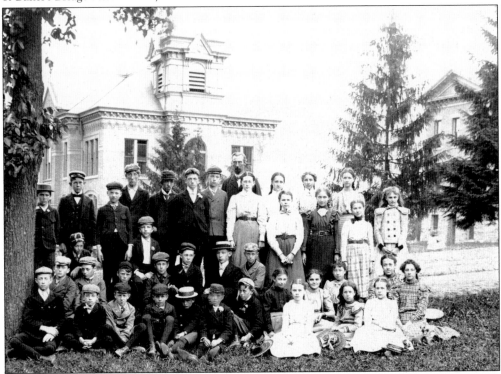

Constructed in 1884, the Alfred Grammar School provided education for students living in the village. It suffered a major fire in 1907 that necessitated a new school building on Park Street. The original structure became the property of Alfred University, which rebuilt it for use as classrooms and faculty office space. (Courtesy of Alfred University Archives.)

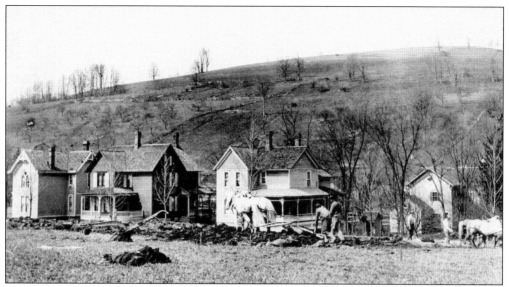

Ground was broken on Park Street in 1908 to prepare to build the new Alfred Union Free School (today's South Hall on the university campus) after the original one (today's Kanakadea Hall on the university campus) sustained a heavy fire the year before. (Courtesy of Alfred Historical Society.)

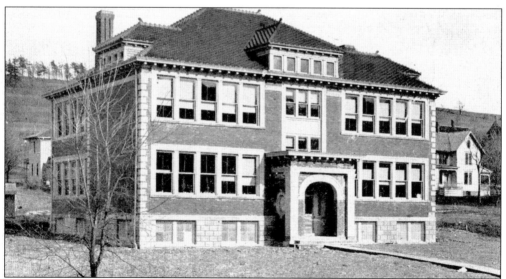

The village's grammar school (completed in 1909), on Park Street, replaced the facilities once housed in today's Kanakadea Hall. After the Alfred Academy closed in 1915, high school students also began attending here. It was no longer used for public education when the Alfred-Almond Central School opened in 1940. (Courtesy of Alfred University Archives.)

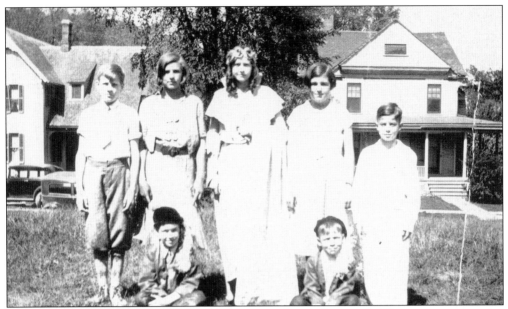

Students at the Alfred Central School often put on plays and musicals. These actors are posing on the school lawn along Park Street during the 1931–1932 school year. From left to right are (first row) Robert Camenga and ? Burdick; (second row) Walter Taylor, Bernice Jacox, Bula Burdick, Hilda Jones, and William B. Crandall. (Courtesy of William B. Crandall.)

The Alfred High School senior play in 1920 featured, from left to right, (first row) Ruth Randolph, Ruth Whitford, Elizabeth Burdick, Vida Randolph, Mabel Fenner, and Helen Thomas; (second row) Prentice Stillman, Howard Gould, Fred Palmer, and Elsworth Burt. (Courtesy of Baker's Bridge Association.)

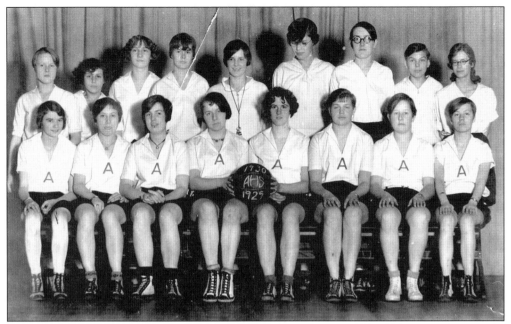

The Alfred High School girls' basketball team poses for its 1929–1930 team photograph. (Courtesy of Baker's Bridge Association.)

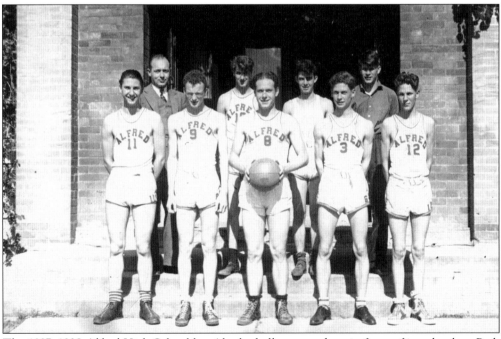

The 1937–1938 Alfred High School boys' basketball team gathers in front of its school on Park Street. From left to right are (first row) George Kamakeras, James Scholes, Louis Stillman, George Potter, and Laverne Palmiter; (second row) coach Robert Howe, Ronald Palmiter, William B. Crandall, and manager Bert Richmond. (Courtesy of William B. Crandall.)

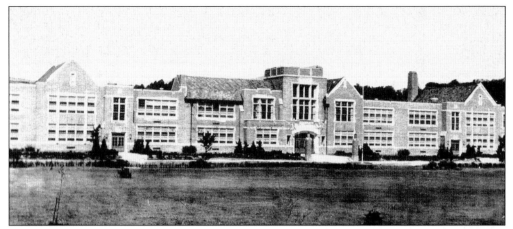

Dedicated in June 1940, Alfred-Almond Central School encompassed the former school districts in Almond, Alfred, Hartsville, West Almond, Ward, and part of Hornellsville. The original building has been enlarged and improved a number of times. (Courtesy of Alfred University Archives.)

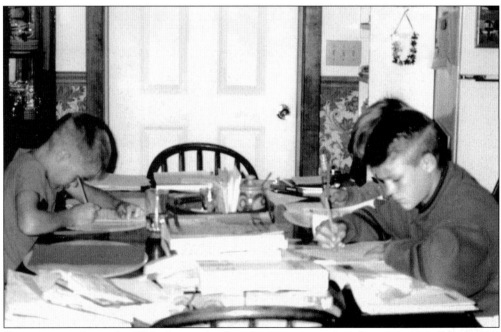

Beginning in the early 1980s, homeschooling became a popular alternative to public school education in Alfred when about 10 families (with over 30 children) opted for this approach. Some developed a cooperative effort in the areas of music, art, and physical education, rotating instruction for the different age groups two days each week. From left to right, Josh, Andrew, and Aaron McGraw are working on their assignments in September 1992. (Courtesy of Sandy McGraw.)

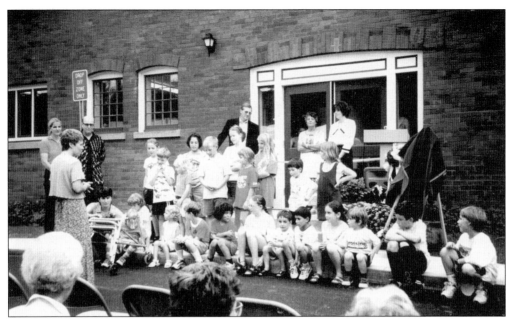

Alfred's Montessori School, opened in 1983, was originally housed on the Alfred University campus. Current and past students perform a song with teacher Pam Bell during the September 8, 2001, ribbon-cutting ceremony for the school's new home in the recently renovated Crandall Barn on South Main Street. Standing behind the children, are, from left to right, unidentified, John Gill, Charles Edmondson, Angela Rossington, and Cathleen Johnson. (Courtesy of Angela Rossington.)

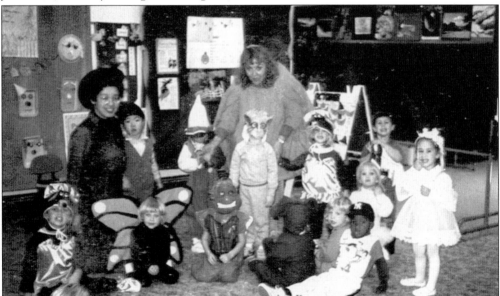

The Alfred Playskool formed in the late 1960s and is best remembered under the tutelage of Patricia C. Hale, who purchased it in 1973. It was housed in various locations in the village before settling at the Alfred United Methodist Church, which took over the program when Hale retired in 1991. Hale, right, is seen here in October 1990 in her famous pumpkin costume along with her students and staff member Keiko Takeuchi. (Courtesy of Laurie DeMott.)

This late-1960s photograph nicely shows the village triad: Alfred State College (lower), Main Street with its homes and businesses (middle), and Alfred University (upper). (Courtesy of

Alfred University Archives.)

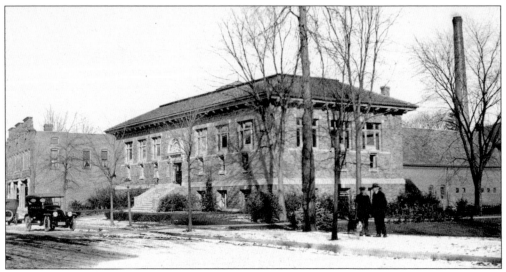

Opened in 1913, the university's Carnegie Library was constructed with money from well-known philanthropist Andrew Carnegie. Helping to influence that donation was Melvil Dewey, who attended the university for a short time. The building to the left is Greene Hall, while the structure behind the library is the livery stables. (Courtesy of Alfred University Archives.)

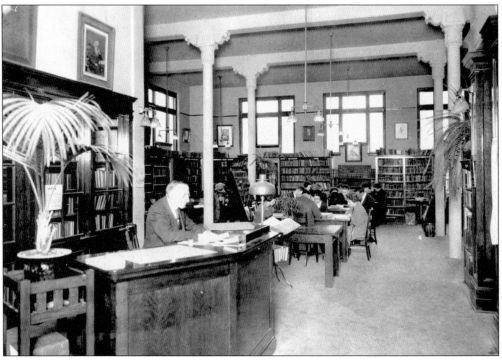

Many alumni and community members fondly recall time spent studying in the university's Carnegie Library. Cortez Clawson, pictured here at the main desk around 1922, became the university librarian in 1910. After Herrick Memorial Library was constructed in 1957, this classic interior was converted to office space for the university's administration. (Courtesy of Alfred University Archives.)

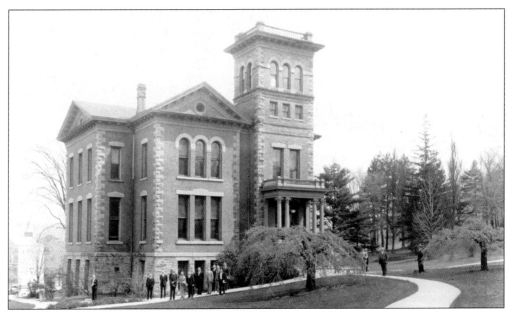

William C. Kenyon, for whom this memorial hall was named, was the first president of Alfred University. The building's tower was used in World War II for spotting overhead airplanes as part of the civil defense program. In the foreground of this 1930s photograph are two Camperdown elm trees, one of which still survives. (Courtesy of Alfred University Archives.)

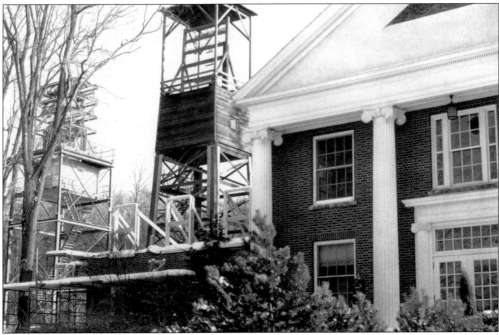

A carillon was acquired in 1937, after many months of fund-raising and work by the Alfred community to memorialize university president emeritus Boothe Colwell Davis and his wife, Estelle. The original wooden tower was replaced in 1953 with the current steel tower. Susan Howell Hall, in the foreground, was also expanded the same year. (Courtesy of Alfred University Archives.)

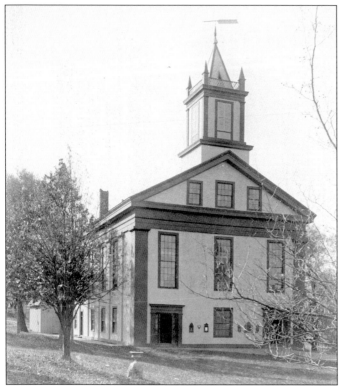

Designed by Maxson Stillman, Alumni Hall was built in 1851 and is the university's oldest building. Shown here in 1896, it came close to being demolished in the early 1980s but thankfully was restored and continues to be an important part of the campus. (Courtesy of Alfred University Archives.)

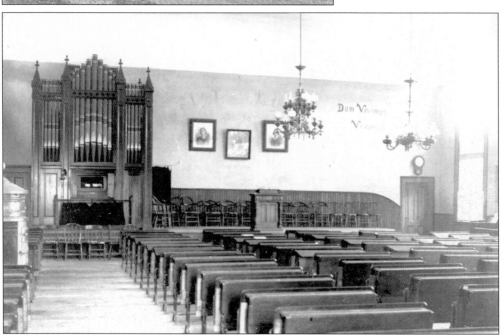

The interior of the university's Alumni Hall, originally called Chapel Hall, looked much different in 1895 than it does today. For much of the later 19th century, students were required to attend daily chapel services here. More contemporary alumni remember this building as the site of their 8:00 a.m. Western Civilization classes. (Courtesy of Alfred University Archives.)

Still widely revered today, Abigail and Jonathan Allen, who spent their careers leading Alfred University, are remembered for their devotion to education and for believing in equality for all people. Their home was the White House, or Middle Hall, situated next door to the Steinheim Museum, which, when first opened, housed much of their personal research collections. (Courtesy of Alfred University Archives.)

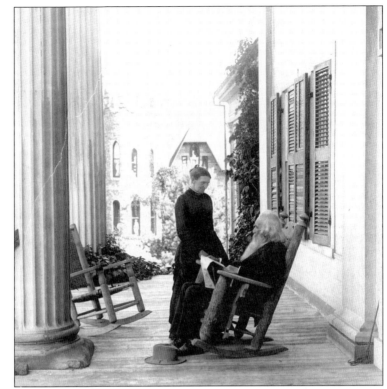

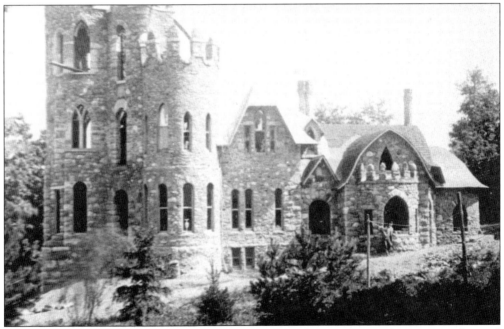

Designed by then university president Jonathan Allen, the Steinheim's design was influenced by castles he had seen on the Rhine in Germany. Construction began in 1876 and ended with Allen's death in 1892. Originally built as a natural history laboratory for Alfred University, it now houses the career development center. (Courtesy of Alan Littell.)

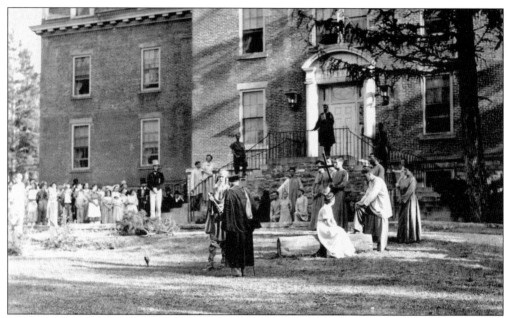

Alfred University celebrated its centennial in 1936. A pageant, written by Elsie Binns and performed on the lawn of the Brick, depicted various scenes from the university's history. University president emeritus Boothe Colwell Davis is seen here accepting the Alfred jewel from none other than King Alfred himself. Local lore says that the town was named after King Alfred. (Courtesy of Alfred University Archives.)

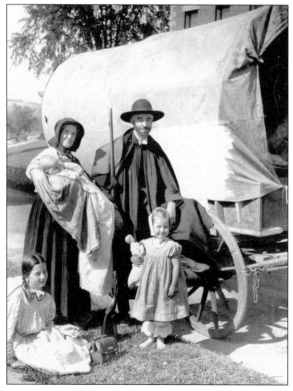

Alfred University's centennial celebration featured many people dressed in period costume. Seen here portraying the David Stillman family (one of the early settlers who arrived in Alfred with his family in a covered wagon in 1818) are, in front, Genevieve Polan (left) and Judith Burdick, and in the back, Erma Hewitt (left) is holding baby Barbara Borass while Samuel R. Scholes Sr. looks on. (Courtesy of Judith Burdick Downey.)

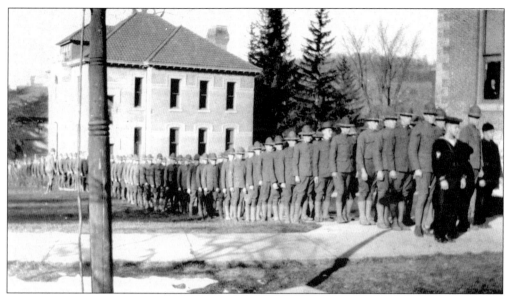

In the fall of 1918, enlistees in a unit of the Student Army Training Corps lived in the university's Brick Hall and conducted their training sessions on campus. They are standing in formation between Kanakadea Hall (left) and Kenyon Memorial Hall. (Courtesy of Peggy and Dan Rase.)

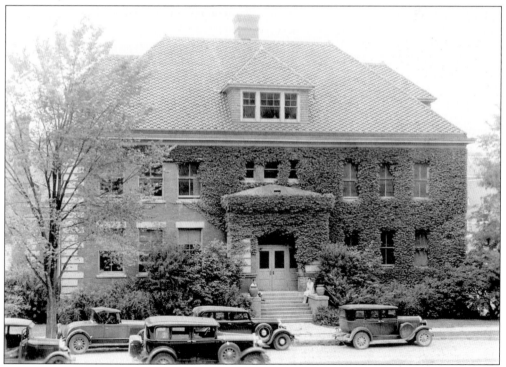

Built in 1900 for the newly formed New York State School of Clayworking and Ceramics, Binns Hall, shown here in 1931 with its terra-cotta tile roof, housed the school's research laboratories, ceramic design shops, and classrooms. Named for the school's first director, Charles Fergus Binns, it was dismantled in 1959. (Courtesy of Alfred University Archives.)

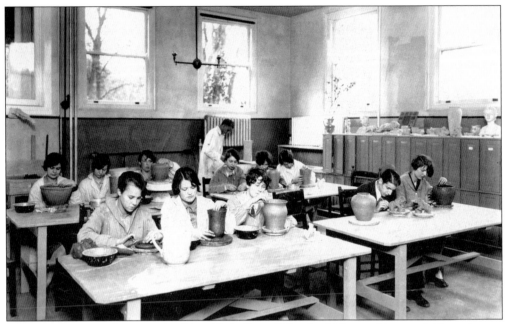

Ceramic design students in the New York State School of Clayworking and Ceramics are working on pinch pots and hand building during a 1920s class in Binns Hall. Notice that the gentleman on the right has created some interesting figures. (Courtesy of New York State College of Ceramics at Alfred University.)

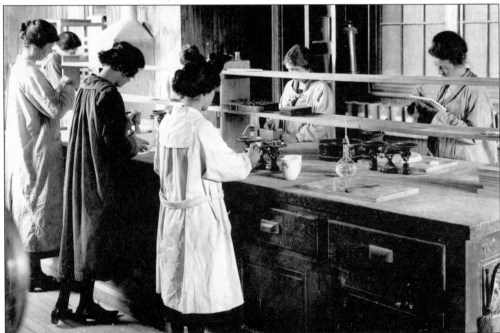

All students in the New York State School of Clayworking and Ceramics, regardless of whether they were enrolled in engineering or art, were required to take chemistry classes in this laboratory on the first floor of Binns Hall. It was, and still is, important for artists to understand the chemistry of clays and glazes. (Courtesy of New York State College of Ceramics at Alfred University.)

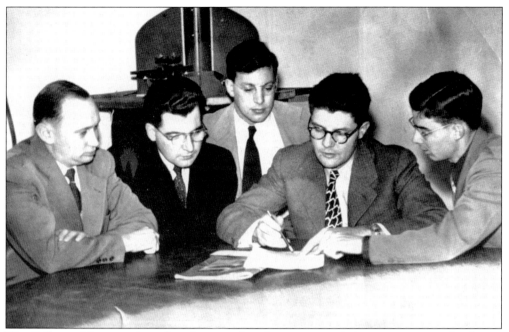

The College of Ceramics has a long history of conducting research for government and industry. Some members of its 1950s research group include, from left to right, James Tinklepaugh, Marion Voss, Robert Turnbull, Larry Lawrence (head of the research department), and William B. Crandall. (Courtesy of William B. Crandall.)

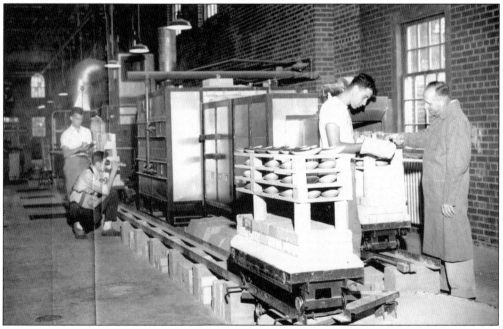

A College of Ceramics professor, Clarence Merritt, right, supervised the St. Patrick's Day celebration for many years, including the making of the annual ceramic favors. Their production, seen here in Binns-Merrill Hall during the 1950s, was a result of effort by both engineering and art students. (Courtesy of New York State College of Ceramics at Alfred University.)

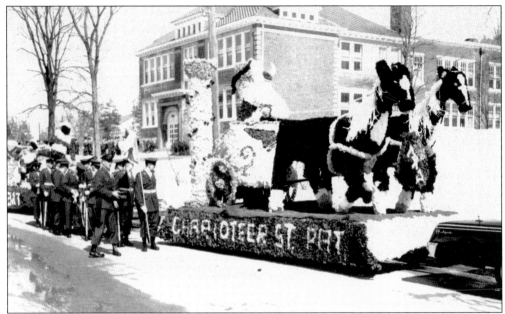

A festival for St. Patrick, the patron saint of engineers, was celebrated at Alfred University for over 50 years. Begun in 1933 by the College of Ceramics, it was initially a way to publicize the college's programs and facilities. Over time it evolved into quite an elaborate festival including a parade, beard-growing contest, and dance. This 1963 parade float is moving down Park Street, past South Hall. (Courtesy of MaryLou Cartledge.)

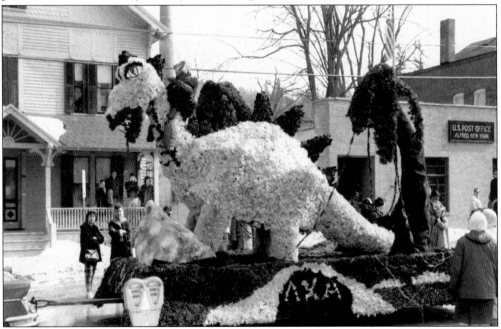

St. Patrick's Day parade floats, often made from paper tissue flowers, were designed by the fraternities and sororities. This one was constructed by Lambda Chi Alpha in 1960. Notice the post office, in the background, which is now the Alfred Pharmacy. The house on the left has since been replaced by a large, brick apartment building. (Courtesy of MaryLou Cartledge.)

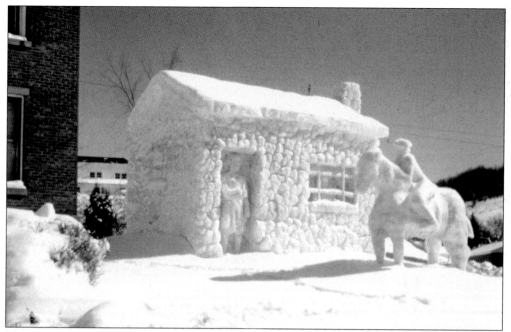

The Winter Carnival, celebrated jointly for many years by Alfred University and Alfred State College, often had amazing snow sculptures created by the students. This one was created in February 1958 by the brothers of the Gamma Theta Gamma fraternity, then located at the Victorian House on the Alfred State College campus. (Courtesy of David Rossington.)

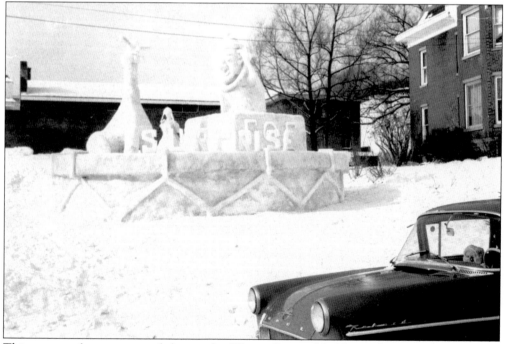

This snow sculpture appeared during the Winter Carnival held in February 1963. Checking it out is 15-month-old Frank Cartledge in his father's 1960 Opel automobile. (Courtesy of MaryLou Cartledge.)

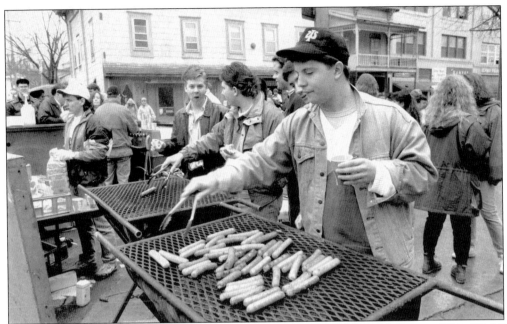

Hot Dog Day began in 1972 as the idea of two university students, Mark O'Meara and Eric "Rick" Vaughn. The event is focused on the ever-popular (and inexpensive) student staple, the hot dog. Jointly sponsored by both campuses, it raises money for local charities and community-based civic organizations. Typically held the third weekend in April, it features a parade, ice-cream social, fun run, mud Olympics, and carnival. Douglas Rouse is busy cooking hot dogs in 1991 (above). Student and professional artists also set up their wares for sale, as seen in this 1990 photograph (below). (Courtesy of Alfred University Archives.)

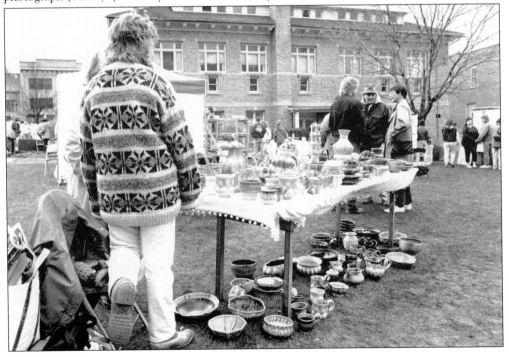

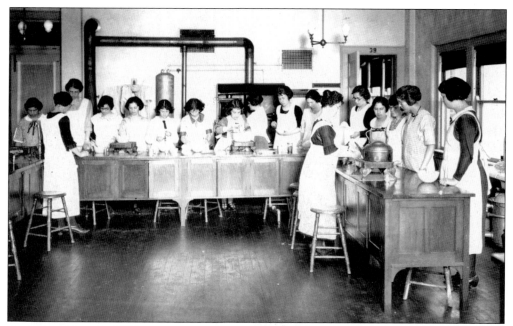

As depicted here in 1925, many young women attended the School of Agriculture for classes in domestic science, which included learning to cook, sew, and manage a household. (Courtesy of Alfred University Archives.)

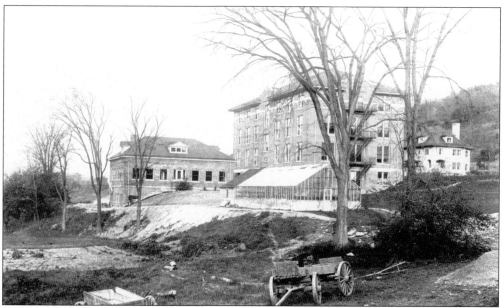

The School of Agriculture, opened in 1908, once occupied land that is now the site of the College of Ceramics' Harder Hall. Shown here, around 1912, are the dairy building, the main classroom and faculty office building, the greenhouse, and the home of Charles Fergus Binns, first director of the College of Ceramics. (Courtesy of Jean B. Lang Western New York Historical Collection.)

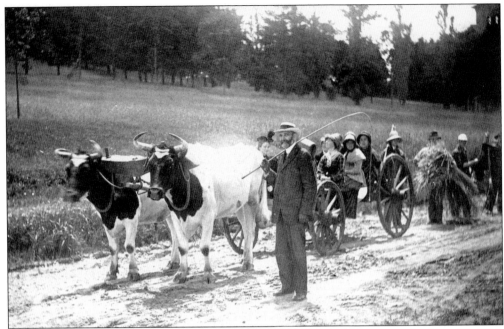

Alfred University president Boothe Colwell Davis leads a team of oxen in the June 22, 1916, School of Agriculture's commencement parade. (Courtesy of Jean B. Lang Western New York Historical Collection.)

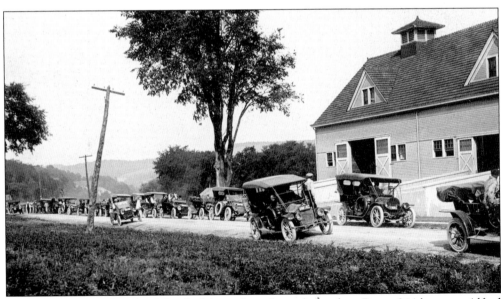

Many people remember the School of Agriculture barns located on Route 244 between Alfred Station and Alfred, but how many remember driving cars like these? Farmers gathered annually at the barn for educational sessions and machinery demonstrations. (Courtesy of Alfred University Archives.)

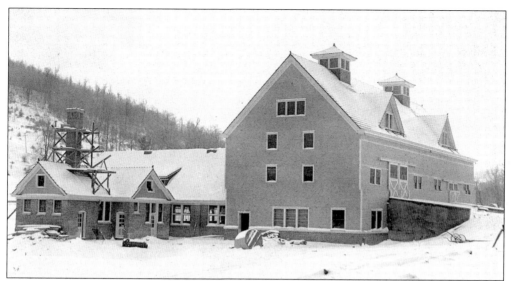

In 1909, the 230-acre Stillman farm on Route 244 was purchased by the School of Agriculture. A new dairy barn and milk house were completed in December 1910, but within two weeks, the barn had been destroyed by fire. It was soon rebuilt to look almost like the original. (Courtesy of Baker's Bridge Association.)

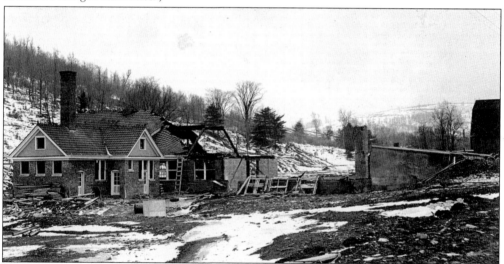

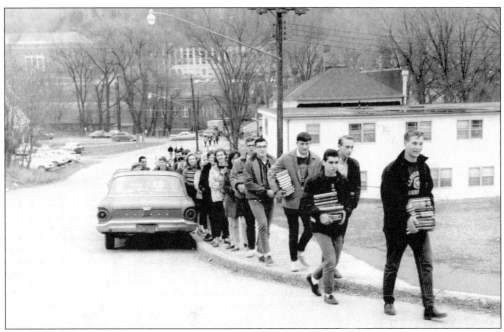

On November 15, 1965, the library for Alfred State College was moved from the original School of Agriculture building on the university campus to its new home, Hinkle Library, a half mile away and across the street. Moving 22,000 volumes was accomplished in four hours with the help of many students who, while carrying an armload of books, walked in order from one building to the other. (Courtesy of Alfred State College Archives.)

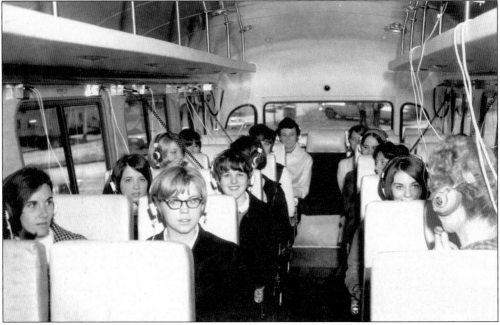

One way for these 1960s Alfred State College nursing students to maximize their time was to listen to instruction on their way to the hospital for clinical work. (Courtesy of Alfred State College Archives.)

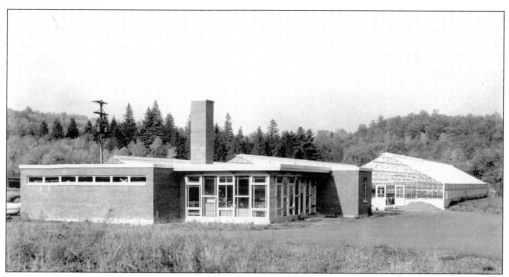

In 1958, the flower shop and greenhouses at Alfred State College's Anderson Horticulture building were opened. For many years, the senior horticulture students prepared a spring open house, which was very popular with local residents. As the college's curriculum changed, the flower shop closed in 2003, and the greenhouses were torn down two years later. (Courtesy Alfred State College Archives.)

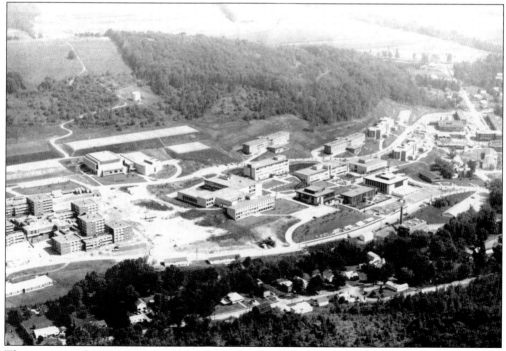

The summer of 1971 was one of expansion for the Alfred State College campus. (Courtesy of Alfred State College Archives.)

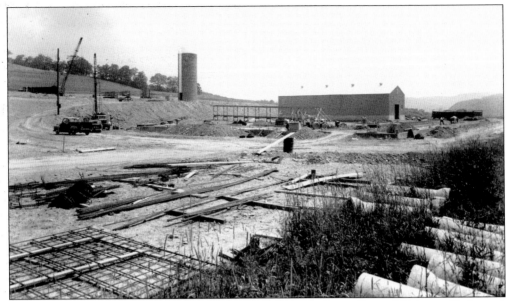

New buildings were added to Alfred State College's farm complex on Route 244 (toward Belmont) during the summer 1964. (Courtesy Alfred State College Archives.)

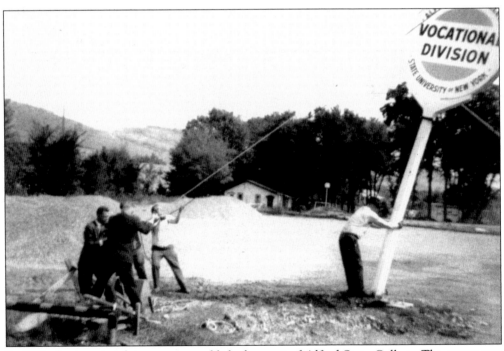

In 1966, the vocational center was established as part of Alfred State College. The center was located on the former site of the Sinclair Refinery in Wellsville, and this photograph shows the repainted oil sign being hoisted for the first time with its new name. (Courtesy of Jean B. Lang Western New York Historical Collection.)

Four

RELIGION

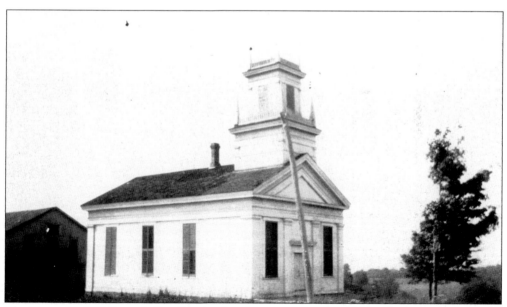

The Hartsville Hill Seventh Day Baptist church was organized in 1849 and was active for almost a century. For many years, it served as a practice congregation for students attending Alfred University's School of Theology. Unfortunately, the building was destroyed by a fire in the 1960s. (Courtesy of Baker's Bridge Association.)

Alfred has been home to a wide variety of religious groups and has hosted numerous regional and national conferences such as this one in 1937: the Fifth Annual Young People's Summer Conference of the Episcopal Diocese of Western New York. (Courtesy of Alfred University Archives.)

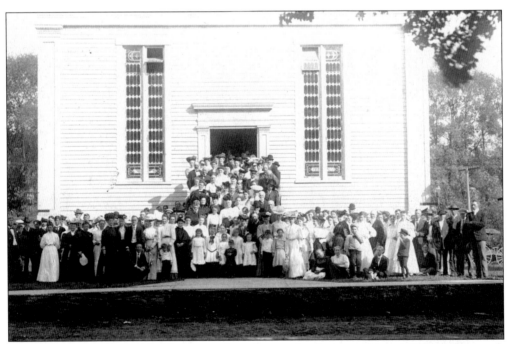

The Seventh Day Baptists hold an annual conference for their members at different sites each year. Pictured here are the 1906 attendees gathered on the steps of the Alfred Station church. (Courtesy of Baker's Bridge Association.)

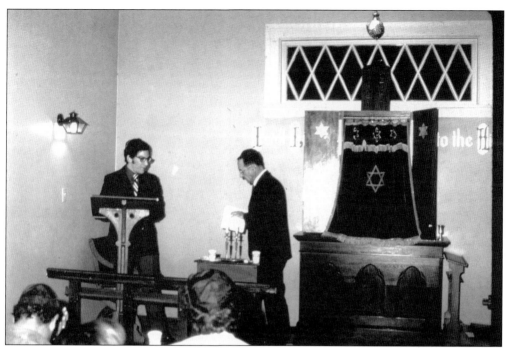

The Jewish student organization Hillel began in 1949 under the direction of Melvin Bernstein, pictured above leading a service in the university's Gothic chapel in 1970. The Melvin H. Bernstein Hillel House at 18 South Main Street was dedicated in 1995. Attending the ceremony are, from left to right, Alfred University president Edward G. Coll Jr., Barbara Bernstein, Judith Leondar, and Arthur "Larry" Greil (who took over as advisor from Bernstein in 1979). (Courtesy of Hillel.)

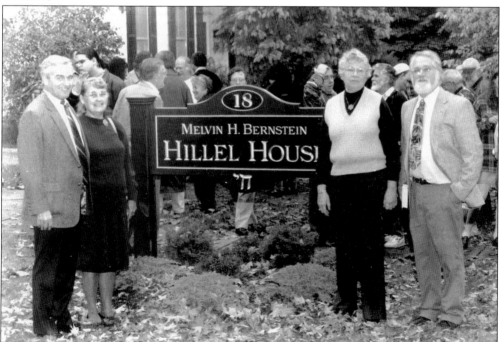

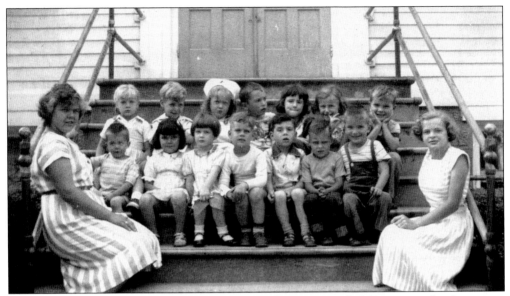

Young attendees at vacation Bible school during the summer of 1960 pose on the front steps of the Alfred Station Seventh Day Baptist Church. Assistants to the director Rena Clarke are sitting with the children: Elaine Schnautz (left) and Beverly Faisst. The children are, from left to right, (first row) Dickie Davis, Margaret Willard, Janice Stearns, Charles Burdick, David Stuck, James Green, and Peter Hornbeck; (second row) Joann Jefferds, Michael Burton, Cynthia Rogers, Andrew Kolstad, Beverly Champlin, Mary Lou David, and Peter Emerson. (Courtesy of Baker's Bridge Association.)

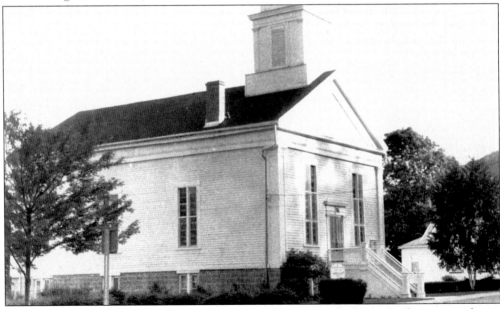

The Second Seventh Day Baptist Church of Alfred was formed in 1831. Its first meetinghouse was located on Pleasant Valley Road, but since 1857 the congregation has worshiped in this building in Alfred Station. Of structural interest, in 1889, the church was raised, moved back from the road, and set on a basement, just in time to avert major damage from a flood in June of that year. (Courtesy of Baker's Bridge Association.)

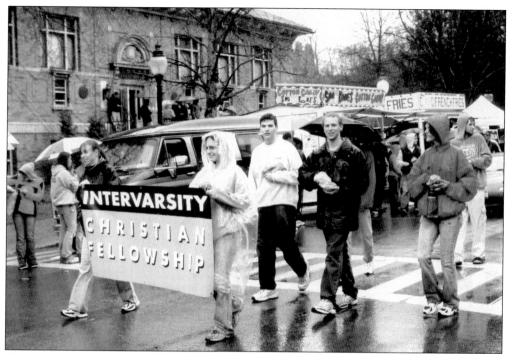

Today's chapter of InterVarsity Christian Fellowship had its start in the late 1970s when several local couples began a successful and sustained Christian ministry to the local colleges. In 1994, they officially affiliated with the International InterVarsity organization. Sunday morning chapel services in the university's Susan Howell Hall are currently attended by 60–90 students who lead the worship, accentuated by special speakers and volunteer staff. Other aspects of the ministry include service projects, Bible studies, fellowship meals, and retreats. (Courtesy of Sandy McGraw.)

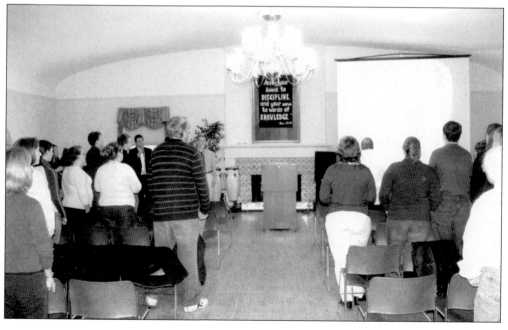

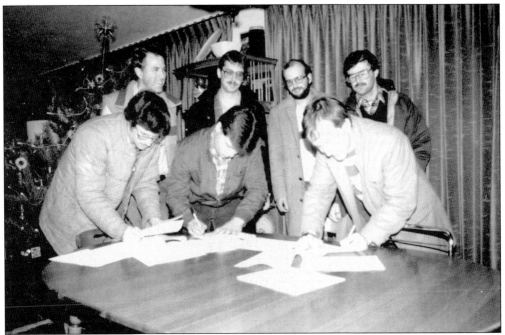

Located on Randolph Road, the Lighthouse Christian Fellowship was formed in January 1985. Signing the original charter are, from left to right, (first row) Alan Burdick, Mark Lawrence, and Craig Mix; (second row) Robert Volk, Roger Gardner, Gerald Snyder, and David Snyder. (Courtesy of Sherry Volk.)

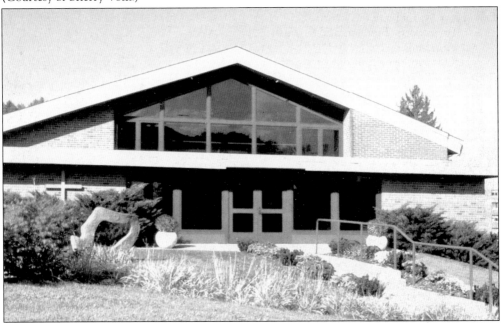

St. Jude's (Roman Catholic) Chapel, located on the Alfred State College campus, was dedicated in 1959. Before its construction, a priest traveled from nearby St. Bonaventure University to conduct Sunday mass services. Today it serves students, faculty, and staff from both Alfred University and Alfred State College, as well as area residents. (Courtesy of St. Jude's Chapel.)

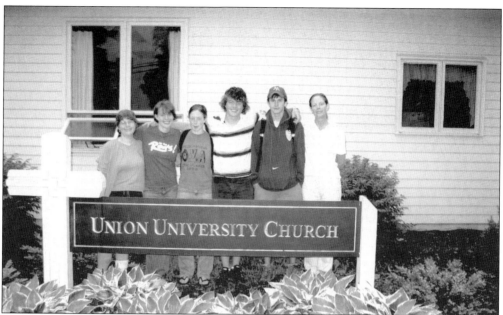

The Union University Church was organized on September 1922 as a response to the need of area residents who were accustomed to observing Sunday worship. Since its founding, its worship services have been held in the Alfred Seventh Day Baptist sanctuary, a unique but mutually beneficial situation. The church offices and meeting rooms are located across the street in the former W. H. Bassett house on the corner of Church and Main Streets. Pictured in the photograph above are members who ventured on a summer 2006 service trip to the Dominican Republic. From left to right are Rev. Laurie DeMott, Nora Visscher-Simon, Emma Dosch, Brian Butts, Brenden McDonough, and Petra Visscher. For many years, the church has hosted a fund-raising bazaar and luncheon each December that is well supported by community members, as can be seen in the photograph below. (Courtesy of Union University Church.)

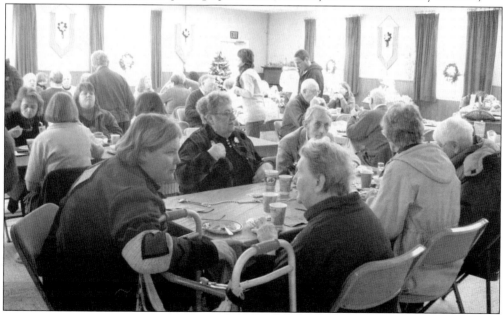

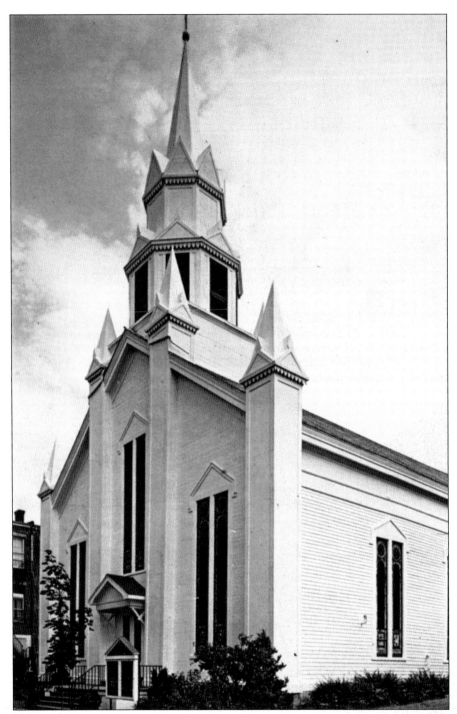

The First Alfred Seventh Day Baptist Church was organized in 1812 and has worshipped in this building on Church Street since it opened in 1854. The denomination had a major influence on the early university and on the development of the village and town as members were prominent university faculty, leaders of civic organizations, and owners of many local businesses. (Courtesy of G. Douglas Clarke.)

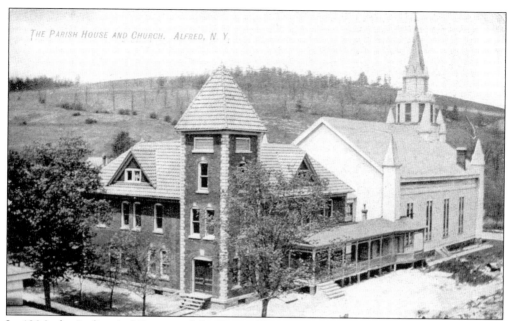

In 1906, the Ladies Aid Society of the First Alfred Seventh Day Baptist Church opened the Parish House on West University Street. With its kitchen, large dining room, parlors, and classrooms, it has provided space not only for church events but also for community groups. (Courtesy of G. Douglas Clarke.)

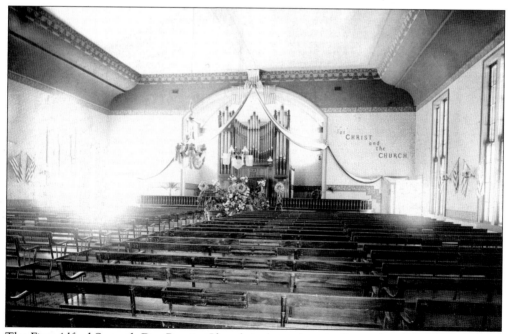

The First Alfred Seventh Day Baptist Church is shown here in September 1901, the same year gas heat and light were installed. The pipe organ and much of the interior were destroyed by fire in 1929. A larger pipe organ was installed the next year when the building was reconstructed. (Courtesy of G. Douglas Clarke.)

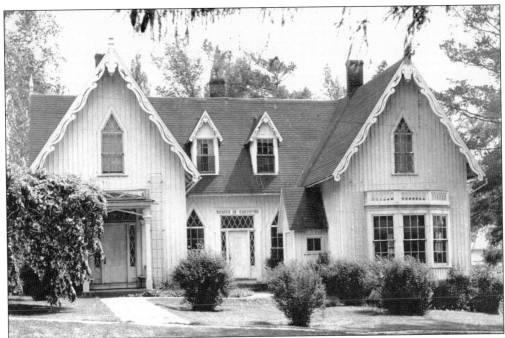

Built in 1851 by Samuel S. White, the Gothic chapel was acquired by the university in 1876. It was used for a variety of purposes (classrooms, student housing, and storage) until it became the home of the School of Theology in 1901. In 1953, while most of the building was razed to make room for Herrick Memorial Library, the chapel section was saved by Hazel Humphreys (pictured below in the chapel) and moved to a lot next to her home on the corner of Ford and Sayles Streets. Humphreys was also well known for her love of books (she operated the Box of Books store for many years) and her love of animals (she started the donation kiosk on West University Street as a fund-raiser for the Society of the Prevention of Cruelty to Animals). (Courtesy of Alfred University Archives.)

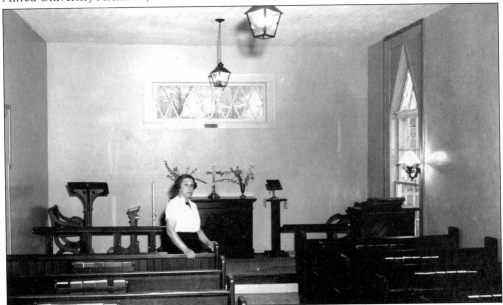

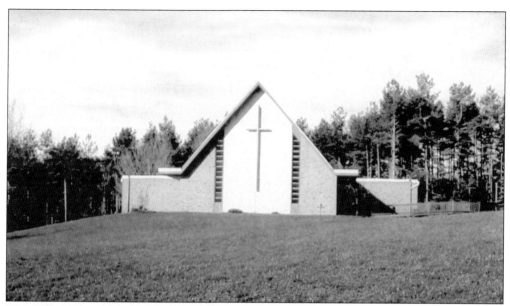

The Alfred United Methodist Church was organized in 1965 after founding members had been affiliated for a number of years with the Wesley Foundation's work with the local campuses. Located on Moland Road, the church building was constructed in 1967. Church members are seen posing after a Palm Sunday service. (Courtesy of Alfred United Methodist Church.)

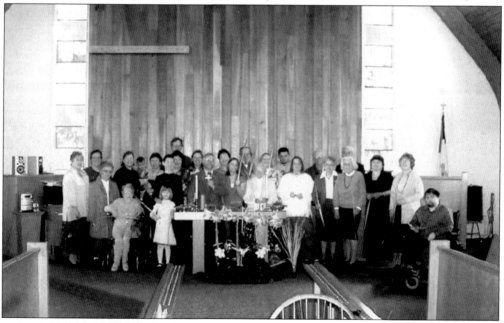

Camp Harley Sutton, situated on land donated by Harold O. and Hannah Burdick, was opened in the early 1950s by the Allegheny Association of Seventh Day Baptist Churches. Located off Pleasant Valley Road, it has provided summer programming for church youth ever since. David Clarke is standing on the lodge porch in 1994. The lodge was constructed with material from the university's first gymnasium, which was torn down in 1953. (Courtesy of G. Douglas Clarke.)

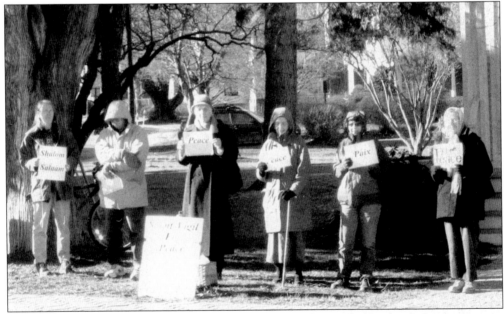

In 1952, the first worship meeting was held for the Alfred Friends (Quakers). In recent years, members and other volunteers can be found on the corner of Main and Church Streets during the Wednesday lunch hour, holding a silent vigil for peace. (Courtesy of Elaine Hardman.)

Five

CIVIC AND LOCAL ORGANIZATIONS

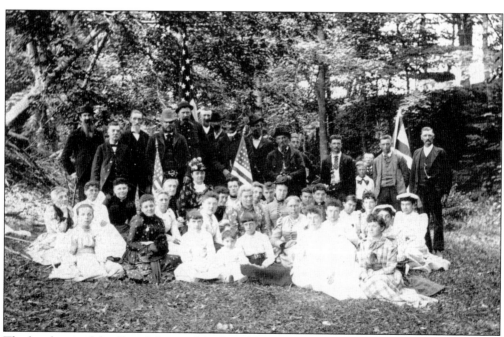

The local post of the Grand Army of the Republic was formed in 1876. Shown here is one of its family picnics. (Courtesy of Jean B. Lang Western New York Historical Collection.)

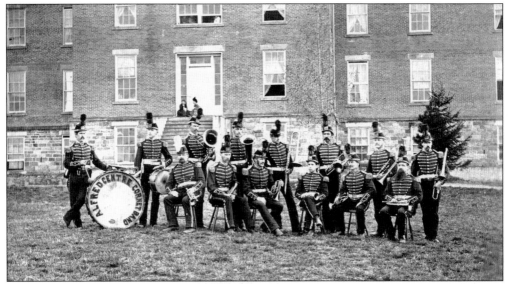

Alfred Centre, the village's name from 1887 to 1895, was home to this well-dressed musical group, the Alfred Centre Cornet Band, which is elegantly dressed in front of the Brick. (Courtesy of Alfred University Archives.)

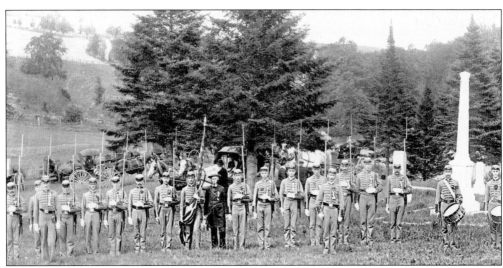

To commemorate Memorial Day, a service is held each year at the Alfred Rural Cemetery. Attending the 1887 service are local Civil War veterans referred to as the Alfred Grays. (Courtesy of Alfred University Archives.)

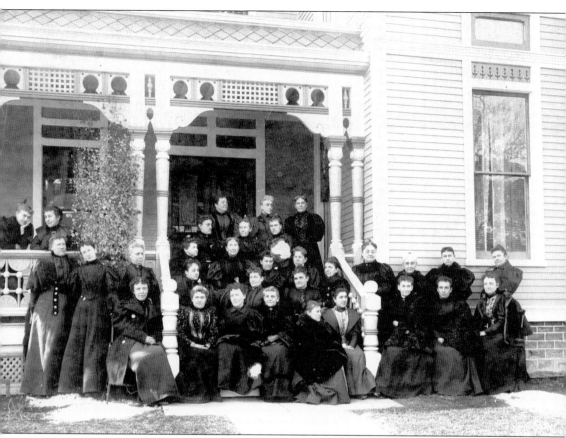

Gathered on the steps of William C. and Amanda Burdick's home at 71 North Main Street are members of the Amandine Club. Still active today, the group began meeting informally in 1893 and formally organized the next year with a focus on cultural and social activities. (Courtesy of G. Douglas Clarke.)

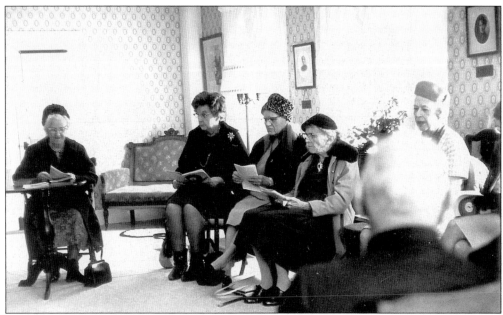

The Champlin Community House on Church Street has been used by local groups and organizations since 1922 as a meeting place. Assembled in the 1960s for one of their "Friendly Forums," part of the Seventh Day Baptist Sabbath School, are, from left to right, Georgia Greene, Ferne Snyder, Mildred Knight, Susan Langworthy, and Helen Ogden. (Courtesy of G. Douglas Clarke.)

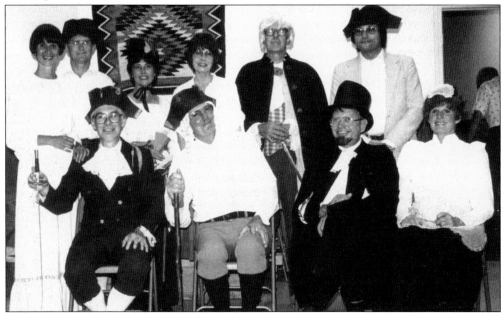

Organized in 1920, Wee Playhouse continues today as a readers' theater for local amateur thespians. Seen here in their 1984 production of *The Rivals* are, from left to right, (first row) David Rossington, Roland Warren, Alan Dirlam, and Esther Smith; (second row) Carol Reed, James Reed, Angela Rossington, Sandy Greiff, Albert Rogers, and Louis Greiff. (Courtesy of Sandy Greiff.)

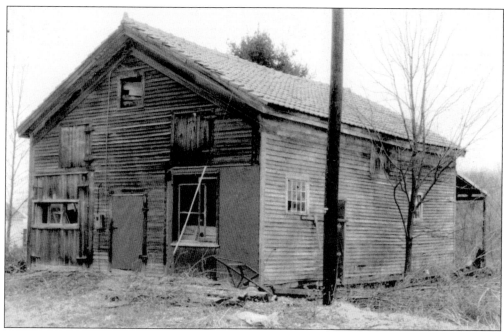

This building, constructed in 1831, was originally the meeting place for the Alfred Station Seventh Day Baptist Church. Initially located in Goose Pasture on Pleasant Valley Road, it was not used after the construction of the present church in 1857. It was later moved to its current site on Hamilton Hill Road and used as a horse barn, shingle factory, and blacksmith shop. The building was donated to the Baker's Bridge Association a few years after it formed in 1976. After many years of work by dedicated members, it has been restored. The association now holds its monthly meetings in the building and stores its historical collections there as well. (Courtesy of Baker's Bridge Association.)

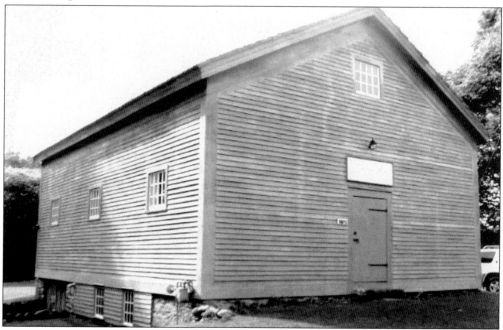

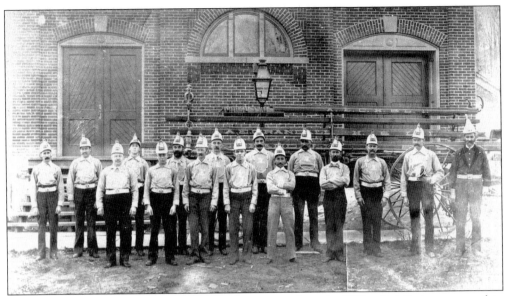

The A. E. Crandall Hook and Ladder Company, seen here in 1903, officially incorporated in October 1889 after having formed two years earlier. Named after Almond E. Crandall, a driving force in creating the organization as well as a major benefactor, it is an essential volunteer organization for the community, providing not only fire protection but also ambulance services and response to other emergencies. From left to right are D. Sherman Burdick, Frank Sisson, William H. Crandall, Daniel Rogers, Winfield Crandall, D. Fred Abbott, Everett Saunders, Fred Potter, Frank Crumb, F. N. Collins, James Carter, Cal Reynolds, John P. Mosier, Lewis Niles, Milo Greene, and Chester Stillman. (Courtesy of A. E. Crandall Hook and Ladder Company.)

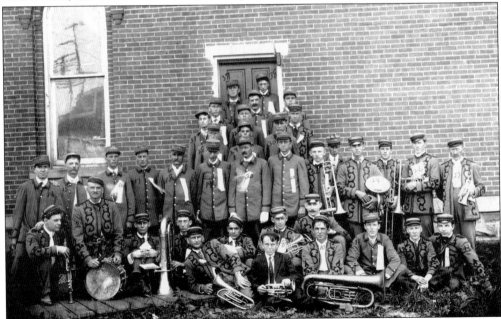

Affectionately known as the "Crandall Hooks," the fire company sponsored a band for many years. Its members are posing by Firemen's Hall around the same time they performed at the 1901 Pan-American Exposition in Buffalo. (Courtesy of Alfred University Archives.)

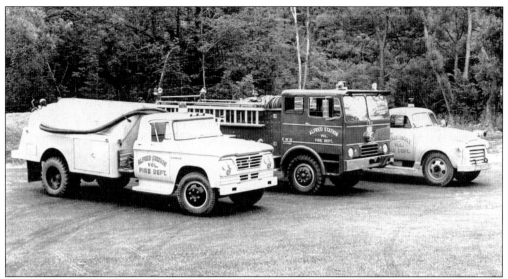

The Alfred Station Fire Company, whose trucks are shown here in 1972, was established in 1912 and has been an invaluable service to the town and village of Alfred. The community is grateful to all who volunteer their time to such important organizations like the fire companies. (Courtesy of Jean B. Lang Western New York Historical Collection.)

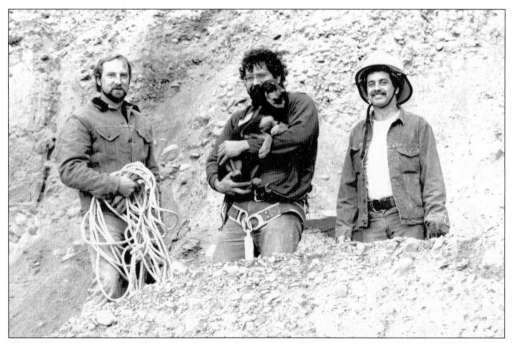

The Alfred Station Fire Company responds to more than just fires. In October 1988, it was called upon to rescue a dog stuck on the hillside of Buffalo Crushed Stone's sand pit. Seen here with the lucky canine are, from left to right, Terry Palmiter, James DeLotto, and Keith Stanley. (Courtesy of Baker's Bridge Association.)

Constructed in 1890, Firemen's Hall has been an important part of the Alfred community, not only as early home to the A. E. Crandall Hook and Ladder Company but also as a community center. Today it houses the village government and police offices. The interior has recently been beautifully renovated through the efforts of dedicated community members. (Courtesy of Alfred University Archives.)

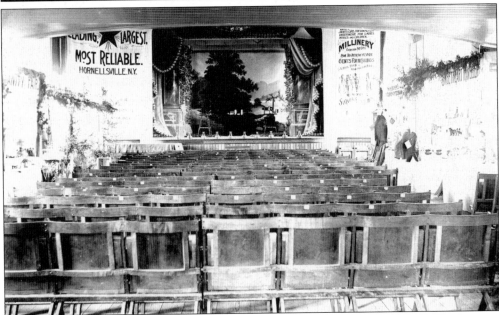

Firemen's Hall (now called Village Hall) hosted numerous theater productions, community events, social gatherings, and the such. It is pictured here in 1898, perhaps for the firemen's annual gala fund-raising event. Note the gas lanterns onstage as well as the interesting displays along the outer walls. (Courtesy of A. E. Crandall Hook and Ladder Company.)

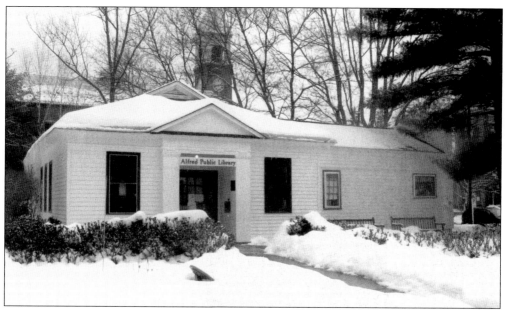

While today it is a public library, the Box of Books was originally established as a bookstore in 1923 by Norah Binns; it was purchased by Hazel Humphreys in 1927. It became the home of the public library in 1985; previously that service had been provided by a traveling bookmobile and a small reading center in Greene Hall. (Courtesy of Laurie Lounsberry McFadden.)

The Box of Books's juvenile collection is housed in the original portion of the building (constructed in the mid-1800s). That section's first location was on Main Street, in the business block across from Carnegie Hall. It was moved in 1912 around the corner, across the street from where it now sits. The adult collection and circulation desk are in a newer part of the building, added in 1987. (Courtesy of Laurie Lounsberry McFadden.)

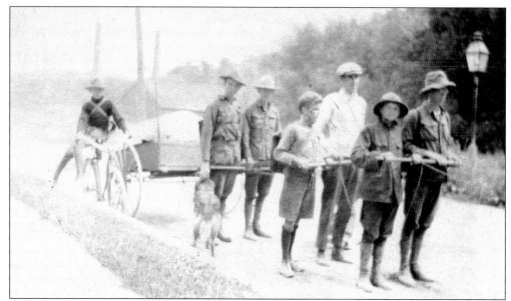

The Alfred Boy Scouts are returning from a trip to Cuba Lake in August 1918. The troop officially organized in 1915 under its first scoutmaster, Ford S. Clarke. (Courtesy of G. Douglas Clarke.)

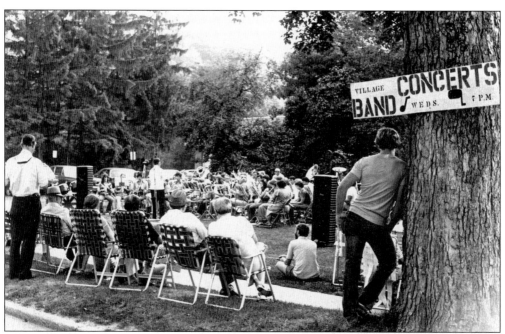

Sitting on the village green on Wednesdays in July is the best place to hear an evening concert while relaxing with family and friends. The Alfred Village Band was formed in 1952 through the efforts of Anthony Cappadonia and Alan Schmidt. At one time the performances were held on the lawn in front of the Box of Books but have since moved across the street where band members play under the protection of the bandstand, built in 1982. (Courtesy of Alfred University Archives.)

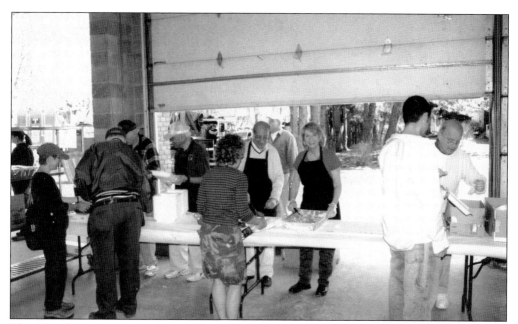

The Alfred Lions Club was chartered in 1966 and has been an active organization raising money for various charitable causes ever since. Serving at one of its annual Stearns chicken barbecues held at the Alfred Fire Hall are, from left to right, Leon Lobdell, Wallace Higgins, Abderrahman Robana, Sheila Foreman, and Maurice Rucker. (Courtesy of Sandy McGraw.)

The Alfred Community Theater was founded in February 2000 by David Snyder and Ellen Shultz for the twofold purpose of getting summer theater going again in Alfred and assisting with the restoration of the 1890 Firemen's Hall Theater. Shown here in the June 2003 production of *Forever Plaid* are, from left to right, Robert Volk, Craig Mix, Brooke Harris, and Shaminda Amarakoon. (Courtesy of Ellen Shultz.)

Members of the Kanakadea Chapter No. 626 of the Order of Eastern Star, chartered in 1919, installed their officers on January 11, 1995, during the first meeting in their new lodge on Karr Valley Road in Almond. From left to right are (first row) Robert Love and Eloise Davis; (second row) Janet Love, MaryLou Cartledge, Jim Sicker, Doris Montgomery, Doug Montgomery, Joy Stuart, Mildred Baker, Adell Jefferds, and Anna Babcock; (third row) Wayne Carter, Gloria Griffin, Nancy Zeliff, Donald Jefferds, Mae Mott, and Evelyn Thomas. (Courtesy of MaryLou Cartledge.)

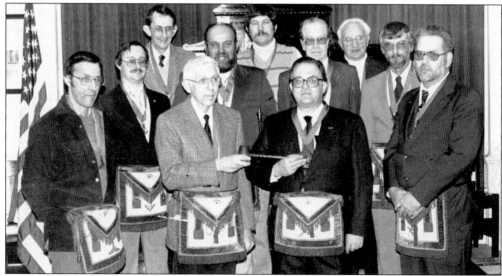

Pictured here in 1987 are officers of the University Masonic Lodge No. 944, which was chartered in 1917. From left to right are (first row) Grover Griffin, Gerald Cartledge, Brian Gillespie, and Paul Henderson; (second row) Ward Votava, Jack Gesner, Berwyn Reid, and Donald Jefferds; (third row) Barrett Potter, David McKee, and Doug Montgomery. (Courtesy of Jean B. Lang Western New York Historical Collection.)

Six

THE POWER OF
MOTHER NATURE

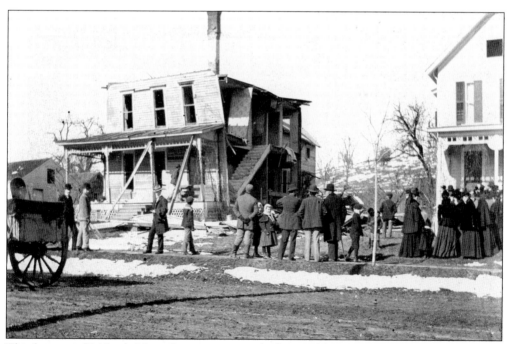

This house at 83 North Main Street was severely damaged by a natural gas explosion around 1900. (Courtesy of Jean B. Lang Western New York Historical Collection.)

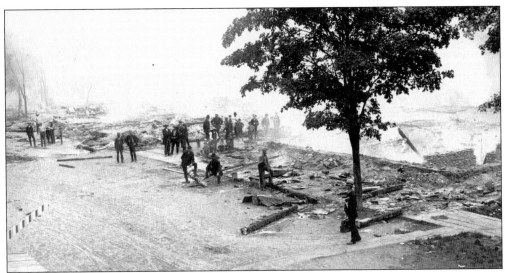

On July 5, 1887, a fire began in the meat market just north of the Burdick Hotel on the village's Main Street. Community members worked quickly to put out the flames but to no avail. Luckily no one was seriously hurt. The fire hastened the formation of a locally organized fire company. (Courtesy of Alfred University Archives.)

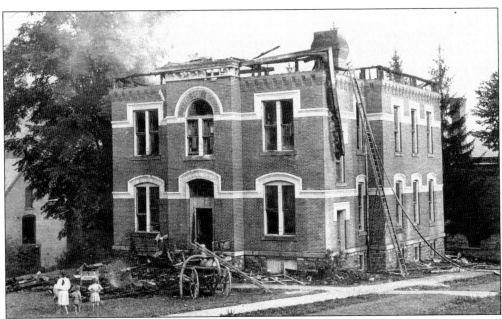

Local children survey the damage caused to the Alfred Centre School in the early fall of 1907. One of Alfred's early fire company water tank wagons can be seen in front of the still-smoldering structure. (Courtesy of Alfred University Archives.)

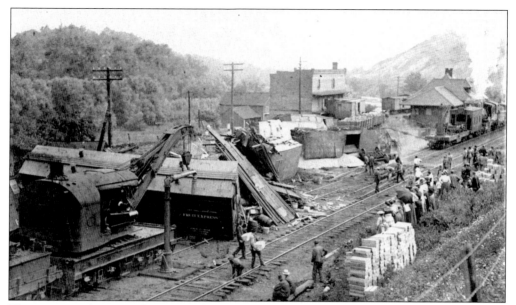

This train wreck occurred on June 14, 1897, at the Alfred Station depot. Not surprisingly, many people turned out to watch the cleanup. The wreck would certainly have caused delays of other scheduled trains and would have needed to be cleared as soon as possible. (Courtesy of Baker's Bridge Association.)

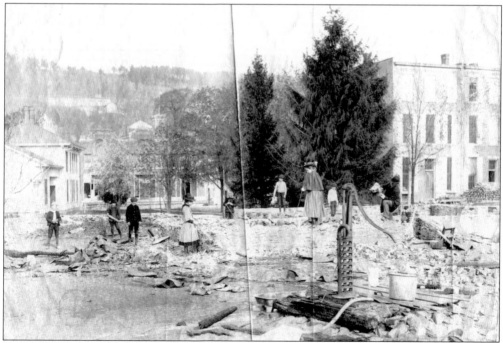

Children sift through the remains of a fire that occurred on Church Street on May 2, 1891. It started in Irving Saunders's photograph studio and eventually destroyed a drugstore, two homes, and the carriage house used by members of the Alfred Seventh Day Baptist Church while they attended weekly services. (Courtesy of Jean B. Lang Western New York Historical Collection.)

A tornado ripped through the area on July 23, 1920, causing extensive damage to many houses, barns, outbuildings, and livestock. George Perkins's barn on Elm Valley Road is just one example. The community rallied to provide general relief and support, including the organization of work parties over subsequent weekends to help people rebuild what they had lost. (Courtesy of Baker's Bridge Association.)

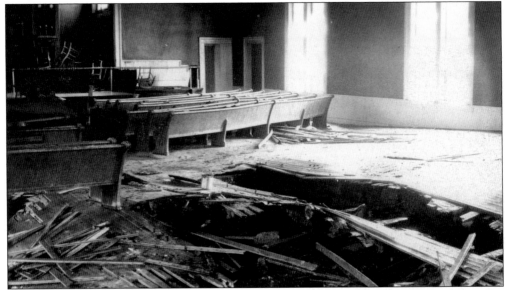

The Alfred Seventh Day Baptist Church was badly damaged from a major fire in early December 1929. The local firemen, assisted by the Almond, Hornell, and Andover fire departments, were able to contain the blaze and keep it from spreading to nearby structures. After some debate, the church decided to restore the building rather than tear it down and build one of brick. (Courtesy of G. Douglas Clarke.)

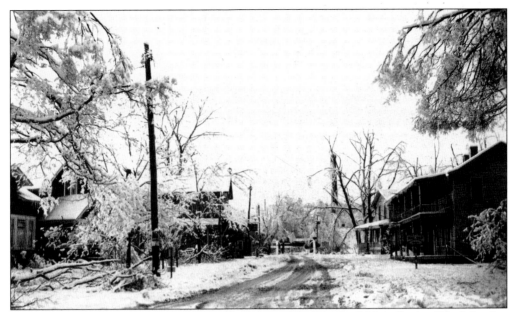

Looking east toward Hamilton Hill Road, this was the March 1936 scene in Alfred Station after the area was hit with an unusually heavy ice storm. Demolished in 1995, the building on the right was once a hotel, built by Daniel Babcock around 1826. It was well situated on a busy thoroughfare, serving visitors and salesmen who had business in town or guests who needed a place to rest as they traveled on the railroad. (Courtesy of Baker's Bridge Association.)

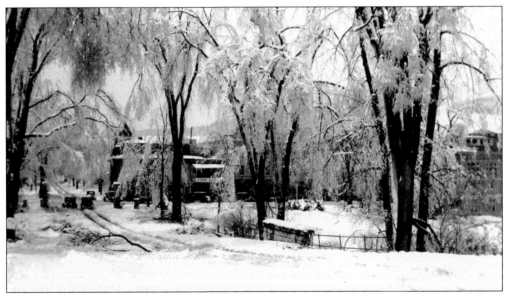

The village of Alfred was also heavily hit during the March 1936 ice storm. (Courtesy of Alfred University Archives.)

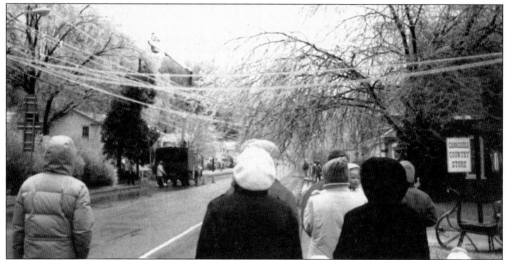

Alfred Station residents, above, watch as utility company crews attempt to ameliorate damage caused by an ice storm in March 1991. Heavy with ice, the trees in front of the Alfred Station Seventh Day Baptist Church, below, managed to withstand their heavy burdens and remain standing strong, unlike many other trees that broke from the weight. (Courtesy of Baker's Bridge Association.)

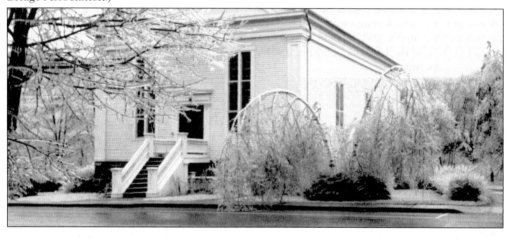

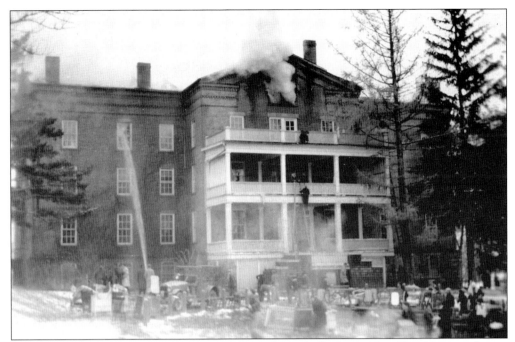

Constructed in 1858 as a university women's residence hall, the Brick suffered a major fire on November 13, 1932. Community members rushed to save it from the consuming fire, which destroyed the cupola and top floor. While they were displaced, the women students were graciously hosted by individual families until the building could be rebuilt. (Courtesy of Alfred University Archives.)

Harold Snyder is examining his damaged tractor in the summer 1956 after his young nephew Ronald Snyder accidentally knocked it out of gear while it was parked on top of the hill in the background. Ronald was able to jump off unscathed while the tractor trundled down the hill, rolled over, bounced around, and ended up a bit out of shape. Harold had it fixed and running within a week. (Courtesy of Harold Snyder.)

Competitions on the university's athletic field were suspended until it could be cleaned of debris left by the July 1935 flood. (Courtesy of Jean B. Lang Western New York Historical Collection.)

Sherman Road was covered with rocks that spilled over from the creek during the 1935 flood. (Courtesy of Baker's Bridge Association.)

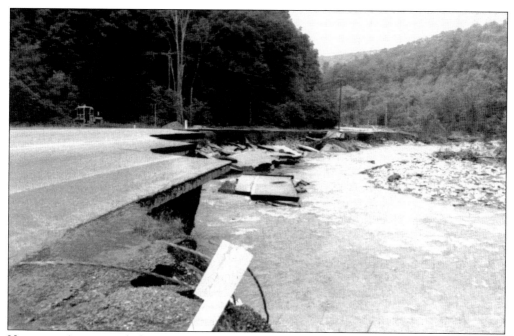

Hurricane Agnes struck the region in June 1972 and is well remembered by many local residents. The white post in the foreground, above, is where the Route 21 highway normally connected to Shaw Road, but the changing creek path wiped out a large section of it. Below, the Alfred Station house on the left lost over 40 feet of its support wall when the creek bank washed away. (Courtesy of MaryLou Cartledge.)

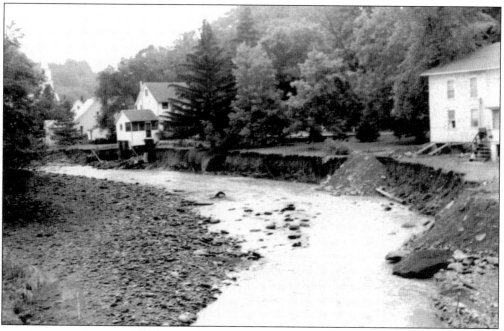

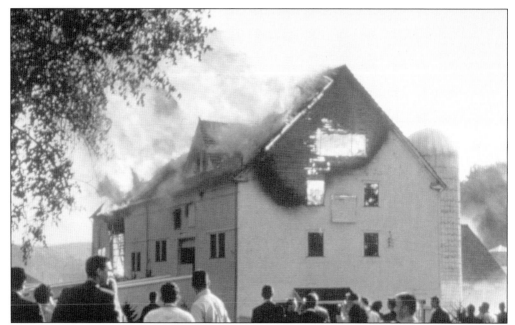

After the School of Agriculture's barn burned in 1910, virtually the same structure was rebuilt on the original spot where it served the school for 50 years before being destroyed on October 2, 1960. Quick work by volunteer fire companies saved the livestock and adjoining buildings. Local farmers offered their barns and services until the farm complex was rebuilt on a new site. (Courtesy of Pete and Kathleen McDonald.)

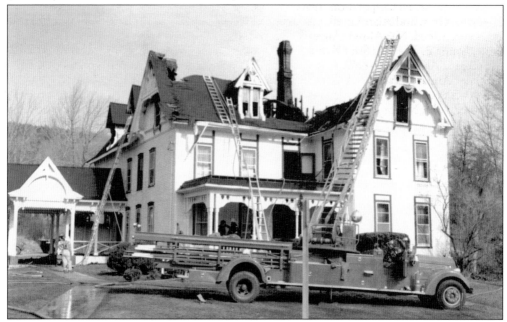

This house at 71 North Main Street was originally the home of William C. Burdick and his wife, Amanda. It became the Delta Sigma Phi fraternity house in 1922 and suffered this major fire in 1981. After the university disbanded fraternities and sororities in 2002, the house was restored and is now the university's Fasano Welcome Center. (Courtesy of Sandy McGraw.)

BIBLIOGRAPHY

Allen, Russell, Thelma Palmiter, and Susan Greene. *Alfred Station Bicentennial Weekend Guidebook*. Alfred Station, NY: Baker's Bridge Association, 1976.

Bernstein, Melvin H. *Art and Design at Alfred: A Chronicle of a Ceramics College*. Philadelphia: The Art Alliance Press, 1986.

Clawson, Cortez R. *History of the Town of Alfred, New York*. Alfred, NY: Sun Publishing Association, 1926.

History of Alfred, New York by the Alfred Historical Society and Baker's Bridge Association. Dallas, TX: Curtis Media Corporation, 1990.

Horowitz, Gary, and Alan Littell, eds. *A Sesquicentennial History of Alfred University: Essays in Change*. Alfred, NY: Alfred University Press, 1985.

Hritz, Elaine B. *The First Sixty Years: A History of the State University Agricultural and Technical College at Alfred, 1909–1969*. Alfred, NY: SUNY Agricultural and Technical College, 1971.

McHale, Anna E. *Fusion: A Centennial History of the New York State College of Ceramics, 1900–2000*. Virginia Beach, VA: Donning Company Publishers, 2003.

Norwood, John Nelson. *Fiat Lux: The Story of Alfred University*. Alfred, NY: Alfred University Press, 1957.

ACROSS AMERICA, PEOPLE ARE DISCOVERING SOMETHING WONDERFUL. THEIR HERITAGE.

Arcadia Publishing is the leading local history publisher in the United States. With more than 3,000 titles in print and hundreds of new titles released every year, Arcadia has extensive specialized experience chronicling the history of communities and celebrating America's hidden stories, bringing to life the people, places, and events from the past. To discover the history of other communities across the nation, please visit:

www.arcadiapublishing.com

Customized search tools allow you to find regional history books about the town where you grew up, the cities where your friends and family live, the town where your parents met, or even that retirement spot you've been dreaming about.